Collins
30 Sketching
minute

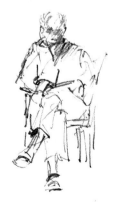

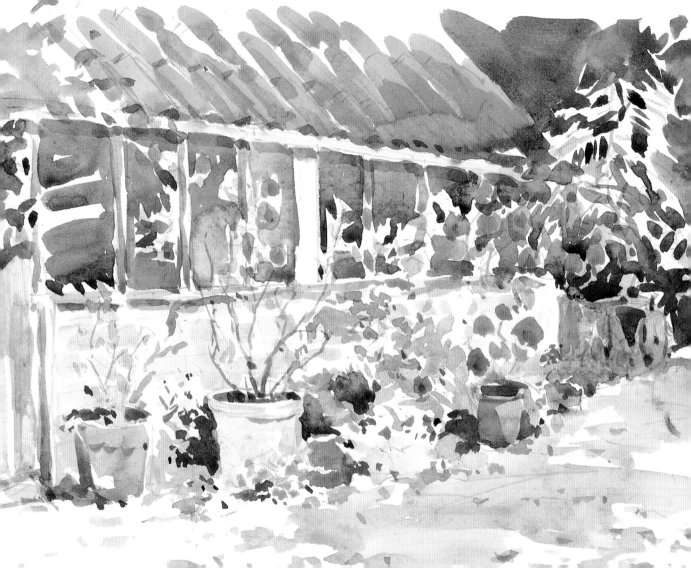

Collins
30
minute

Sketching

Alwyn Crawshaw

First published in 2008 by
Collins, an imprint of
HarperCollins*Publishers*
77-85 Fulham Palace Road
Hammersmith, London W6 8JB

www.collins.co.uk

12 11 10
8 7 6 5 4 3 2

A catalogue record for this book is available from the British Library.

Editor: Diana Vowles
Designer: Kathryn Gammon

ISBN 978 0 00 784850 8

Colour reproduction by Colourscan, Singapore
Printed and bound in China by South China Printing Co. Ltd.

Page 2: **From My Studio**, 21 × 28 cm (8½ × 11 in)

About the Author

Alwyn Crawshaw has written 28 books on art instruction,
all published by Collins. He has a huge following among
amateur painters and has made eight successful TV series
on the BBC, Channel 4 and the Discovery Channel, as well as
many popular videos on painting. Alwyn founded the Society
of Amateur Artists and is President of the National Acrylic
Painters' Association. He is
also a Fellow of the Royal
Society of Arts, an honorary
member of United Artists and
a member of the Society of
Equestrian Artists, the British
Watercolour Society and
several other art societies. He
regularly contributes articles
to *Leisure Painter* magazine.
For more information, visit
www.crawshawgallery.com

PHOTO: NIGEL CHEFFERS-HEARD

Dedication
I would like to dedicate this book to June, my wife, for her continual support
with all my artistic endeavours.

Acknowledgements
I would like to thank all the students I have taught over many years for their
friendship and the professional artists I have had the pleasure of meeting and
exchanging ideas with along the road to learning.

CONTENTS

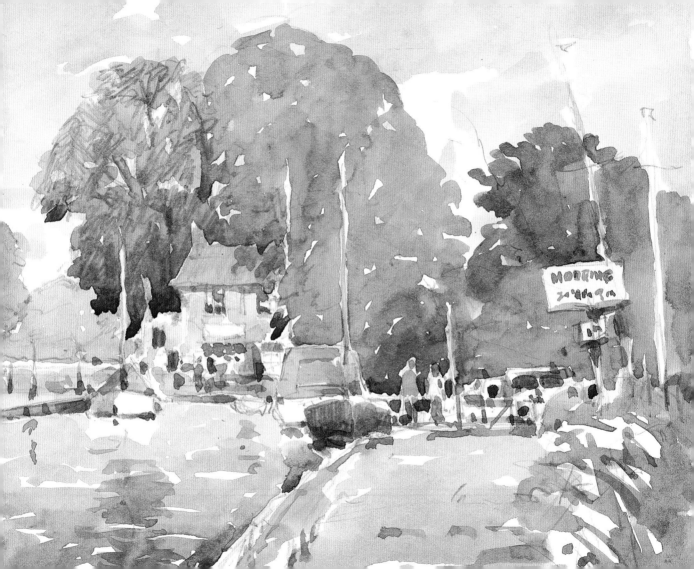

INTRODUCTION

Sketching is the most uplifting and enjoyable way to paint and it is a great teacher, whether you are working with pencil or paint, outdoors or indoors. There is no pressure on you, as you are not painting for an exhibition or to please your friends or family; you are sketching for your own enjoyment. Nevertheless, you can go on to show your sketches in exhibitions.

Because of the relaxed way in which they are done, sketches can often have more energy and dynamism than a highly finished work, and indeed some of the Old Masters' sketches are actually preferred to their exhibition paintings.

◀ **Thurne Dyke**
(detail, actual size)
The most important part of this location sketch was the drawing, as it is a complicated scene with lots of activity.

What is a sketch?

There are three different types of sketches: an **information sketch**, done solely to collect information or detail; an **atmosphere sketch**, where the aim is to record the atmosphere and mood for a finished painting; and an **enjoyment sketch**, done usually on location simply to enjoy the experience. It is the enjoyment sketch that I will concentrate on in this book – the information and atmosphere sketches will develop as you gain experience.

30-minute sketches

Why a limit of 30 minutes? First, it will stop you fiddling and looking for something extra to do in your sketch, which can lose the spontaneity of it – a good sketch can be spoilt by overworking. Secondly, it will teach you how to observe your subject.

Many of the sketches I have done in the book have taken about 30 minutes, though some have taken a little less. Practise the techniques I describe for as long as you need and use the clock only when you have the confidence to start sketching. It is very important to take your time and carefully observe your subject, deciding how you are going to draw or paint it, before you start the sketch or, of course, the clock.

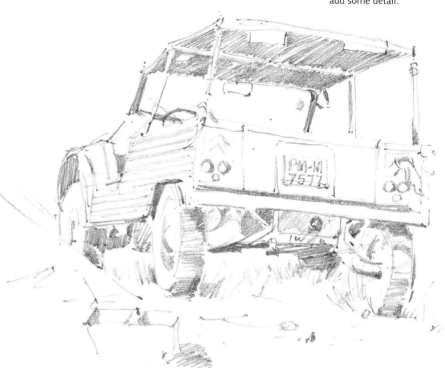

▼ **Spanish Truck**
This information sketch was done with a 2B pencil so that I could quickly put in shading to make the truck look three-dimensional and also add some detail.

The aim of this book

In this book I will take you by the hand and show you how to enjoy your sketching without too much historical and technical information to complicate things. When you were at primary school you would draw or paint without any thoughts of whether it was good or bad – you had no inhibitions, you did it just for your own enjoyment. This is how I want you to approach sketching.

Remember that the 30-minute time limit is a guide only. We all have our own natural speed of working, but in all my 50 years of painting and teaching I have found working to a limited time one of the most inspiring and exciting exercises to do and some of my students' best work has been done this way. So have a go – I know the 30-minute clock will help you.

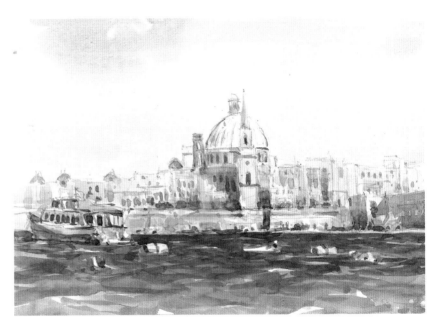

▲ **Valletta, Malta**
20 × 28 cm (8 × 11 in)
This watercolour enjoyment sketch may look more time-consuming, but notice how the distant buildings are done very freely.

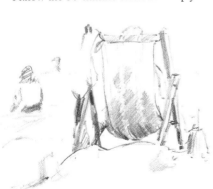

◄ **Beach Deckchair**
I used a 2B pencil to make a quick sketch of a deckchair on a beach while I was on holiday. It was done purely for enjoyment.

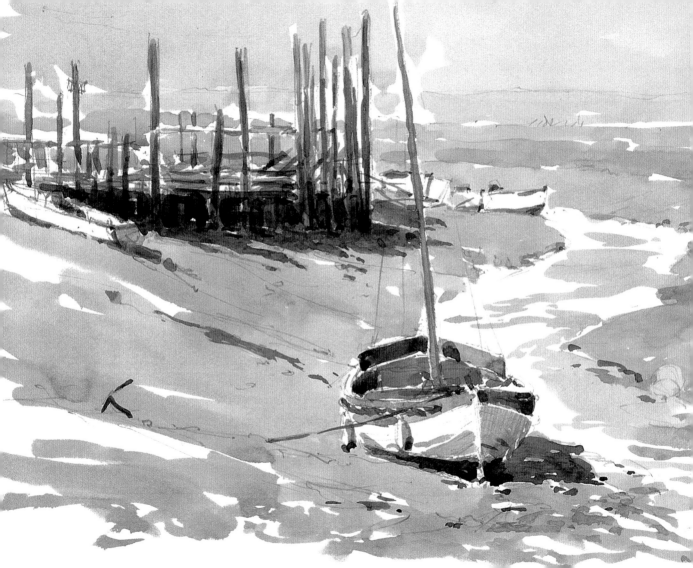

ESSENTIAL EQUIPMENT

For a beginner, going into an art materials shop must be very confusing. There are hundreds of brushes, many different papers and a bewildering choice of sketchbooks, pencils and paints, all invitingly displayed.

However, help is here: on the next two pages I will show you the basic simple materials you should buy. You don't need a large range of equipment for sketching, and for working on location you certainly won't want to carry a lot with you. Keep things simple with your materials at first and get used to them – if you want to try different ones, experience will guide you as you progress.

◀ **Morston Quay, Norfolk**
20 × 28 cm (8 × 11 in)
I painted this on location, using the minimum equipment needed for sketching outdoors.

Pencils

Pencils are available in a range of grades. The most familiar one, which you will find in any stationery shop, is HB. The letter 'H' stands for hard lead, and the range covers 2H, 3H, 4H, 5H and 6H. The hardest pencil is the 6H. On the other side of HB are the 'B' (soft lead) grades – 2B, 3B, 4B, 5B, 6B. The softest pencil is the 6B.

I use a 2B pencil for most of my sketching, but there are occasions when I turn to a 3B or a 6B. These are the three pencils you need for the exercises in this book. You will also require a putty eraser for rubbing out your pencil marks. It is impossible to get everything correct the first time, so an eraser is as important to you as your pencil.

Paper

Unless otherwise specified, all the sketches in this book are on cartridge drawing paper; the remainder are on Bockingford Not watercolour paper. Both can be bought in pads. There are a number of other watercolour papers available, in different weights and surfaces. When I am working outdoors, most of my sketching is done in a Daler-Rowney A4 or A3 cartridge sketchbook.

▼ A basic pencil sketching kit: 2B, 3B and 6B pencils, a putty eraser and sketchpads.

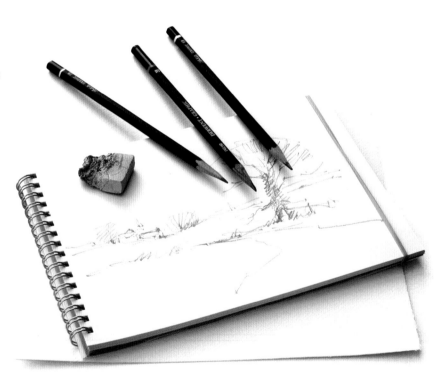

QUICK TIP

To stop your sketchpad pages flapping when you are working outdoors, just slip an elastic band round the outer edge of the pad.

Watercolours

Watercolours come in pans or tubes. I recommend that you don't use tubes, as you can control the amount of paint you put on your brush much more easily from a pan, and a paintbox of pans is much more convenient for sketching outdoors. There are two qualities of paint: students' and artists'. I use artists' quality, but Daler-Rowney Students' Aquafine are very good and less expensive. The seven colours I use are discussed on page 22.

Brushes

The best watercolour brushes are manufactured from sable hair, and they are the most expensive that you can buy. However, there are excellent synthetic brushes on the market that cost much less than sable, and they are used by many professional artists (Daler-Rowney Dalon is one example). I use a No. 10 round brush as my big brush, a No. 6 round as my small brush and a Daler-Rowney Dalon D99 Rigger No. 2 for thin lines. The higher the number, the larger the brush.

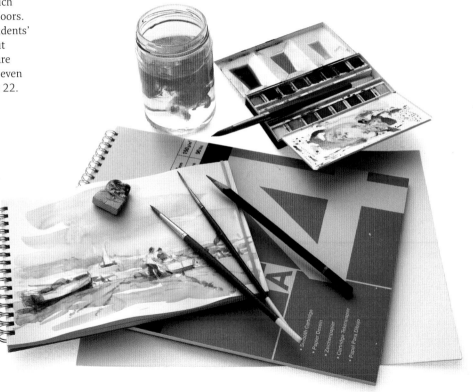

▼ A basic watercolour sketching kit: a water jar, a paintbox, three brushes, a 2B pencil, a putty eraser and sketchpads.

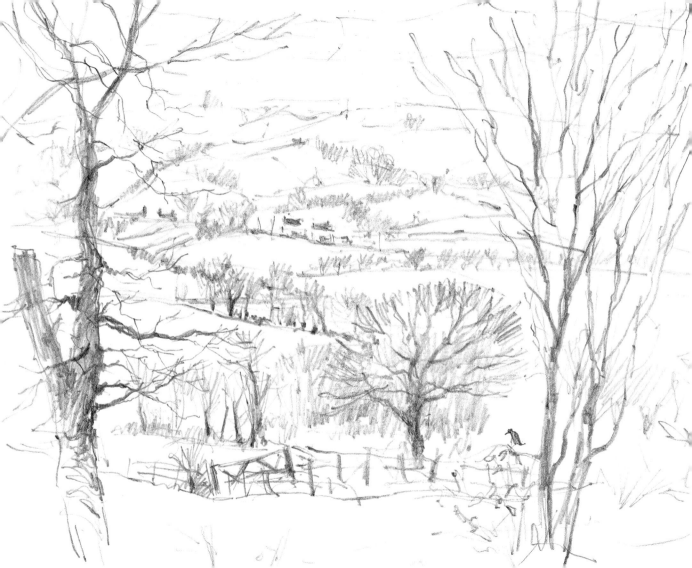

PENCIL TECHNIQUES

The most versatile and convenient sketching tool is the pencil, and it is ideal for making quick 30-minute sketches. Pencil sketching has been done for centuries by world-famous artists; John Constable, England's most renowned landscape artist, took sketchbooks as small as 5 × 10 cm (2½ × 4 in) on his travels.

The best thing about pencil sketching is that if you haven't got any equipment with you, it is always possible to get a pencil and some paper to work on no matter where you are. I have sketched on the back of envelopes and even a long till receipt! In this chapter I will show you how to get the most out of your pencils.

◀ **From Donna and Andrew's Garden**
20 × 28 cm (8 × 11 in)
For this sketch I used a 2B pencil, which allowed me to draw thin branches on the trees.

Using pencils

To get the most variety of line and shading from a pencil when you are sketching there are a few simple things to learn, the most important of which is how to hold your pencil. With the three methods of holding it shown below, your pencil will do whatever you want on your sketch. However, your pencil must be sharpened with a sharp knife to give you a long point, not with a pencil sharpener.

Following the simple exercises shown here will help you to use your pencil effectively. As you do them, practise varying the pressure you put on the pencil to give stronger or lighter lines.

You can also use your eraser as a drawing tool, creating lighter areas in your pencil shading.

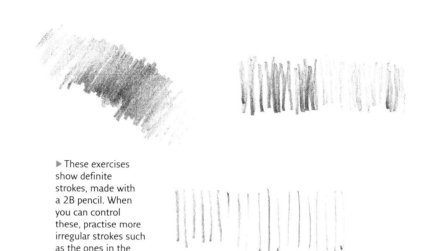

▶ These exercises show definite strokes, made with a 2B pencil. When you can control these, practise more irregular strokes such as the ones in the sketch opposite. Scribble away and enjoy what a pencil can do.

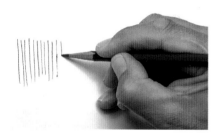

▲ The **short hold** position that you use when writing gives you most control.

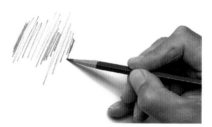

▲ The **long hold** drawing position allows more freedom over a large area.

▲ The **flat hold** position allows you to work large shaded areas with fast, free, broad strokes by using the long edge of the lead.

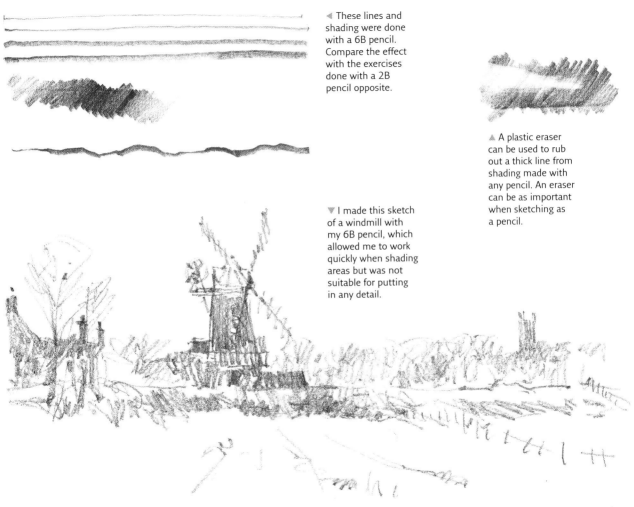

◀ These lines and shading were done with a 6B pencil. Compare the effect with the exercises done with a 2B pencil opposite.

▲ A plastic eraser can be used to rub out a thick line from shading made with any pencil. An eraser can be as important when sketching as a pencil.

▼ I made this sketch of a windmill with my 6B pencil, which allowed me to work quickly when shading areas but was not suitable for putting in any detail.

Comparing pencil grades

The pencil grade you decide to use when you are sketching will depend upon how much detail you want to include in your picture and the overall effect you want to achieve.

Choosing the right pencil
When you are out sketching, time could be against you for all sorts of reasons: the weather, the journey, or perhaps you just want to sketch as many scenes as possible. Therefore speed is essential. The answer on these occasions is to use a 6B pencil. This is also a great way to help you learn to simplify your subject (see page 42). You can't draw in fine detail easily, so you work for a quick overall visual image, not looking for detail. Above all, using this pencil will teach you not to fiddle!

I did these three A4 sketches of a Norfolk lane to show the difference between a 2B, a 3B and a 6B pencil. For the first one I used my 2B pencil and it

took 20 minutes plus experience! The second, using a 3B pencil, has less detail, because the pencil is softer and can cover areas more easily. The last sketch is done with a 6B pencil, and the difference is clear. Because the 6B has a very soft lead it is not easy to draw detail, but it is very easy to shade in areas quickly to give a simplified image. This sketch took minutes to do.

In this first project, sketch with your 2B pencil, then do the same sketch again with your 3B and 6B. Copy any of mine in the book, and try some of your own. I know you will enjoy it. Don't work them smaller than A4 size, and don't worry about time for the moment – working quickly will come.

▲ **2B pencil**
For this sketch I used a 2B pencil, which allowed me to draw some detail in the trees.

▶ **Steamroller**
This was drawn on A3 paper with a 6B pencil. There is no fine detail in the steamroller, but its bulk and strength are very evident.

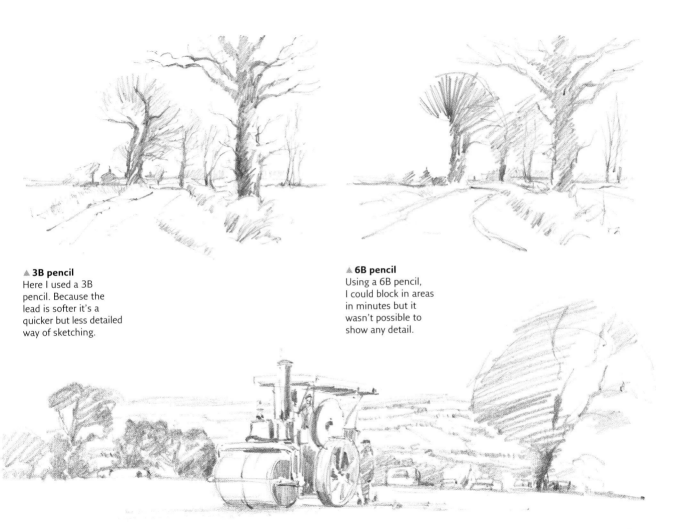

▲ 3B pencil
Here I used a 3B pencil. Because the lead is softer it's a quicker but less detailed way of sketching.

▲ 6B pencil
Using a 6B pencil, I could block in areas in minutes but it wasn't possible to show any detail.

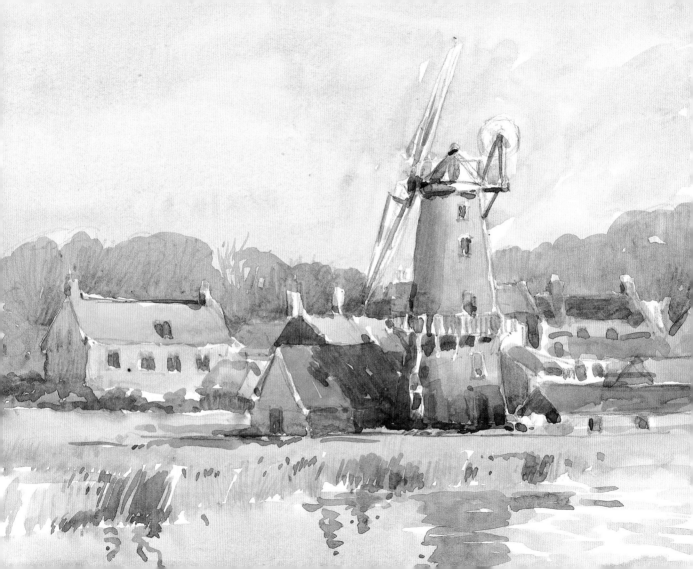

WATERCOLOUR TECHNIQUES

Over a period of time artists evolve some of their own techniques through experience, and this is fine – but there are some basic ones that you will need to practise and become familiar with before you find your own developing.

Watercolour is a very direct medium. Sometimes the quicker you work – with confidence – the better the result. So practise the techniques shown in this chapter and enjoy your watercolour sketching. Remember, time is not the most important aspect of practising. Work at your own speed to gain experience with the techniques, and speed will follow quickly.

◀ **Cley Mill, Norfolk**
20 × 28 cm (8 × 11 in)
This sky was painted with a rough wash and brush strokes gave the water light and movement.

Colour mixing

Mixing your colours is much easier than you might think. By using just three colours, red, yellow and blue, almost all colours can be created. These three colours are called the primary colours. There are, of course, different reds, yellows and blues, which can help in mixing, but I use mainly French Ultramarine, Alizarin Crimson and Yellow Ochre for 80 per cent of my paintings. The other colours I like to work with are Cadmium Red, Cadmium Yellow Pale, Coeruleum and Hooker's Green Dark, and these seven are the only colours that I used throughout the book.

Achieving the right mix

In the colour chart shown here, the three primary colours are in the middle. If you mix red and yellow you make orange and as you add more water to the mix the colour becomes paler. This applies to all colours you mix. Naturally, if you mix more red than yellow your orange will be a reddish-orange, and if there is a greater proportion of yellow you will create a yellowy-orange.

▶ **Colour mixes**
Practise mixing colours, using the ones shown here as a starting point.

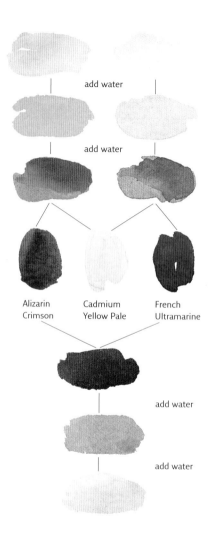

add water

add water

Alizarin Crimson

Cadmium Yellow Pale

French Ultramarine

add water

add water

Cadmium Red

Yellow Ochre

Coeruleum

Hooker's Green Dark

Cadmium Yellow Pale

Hooker's Green Dark

Alizarin Crimson

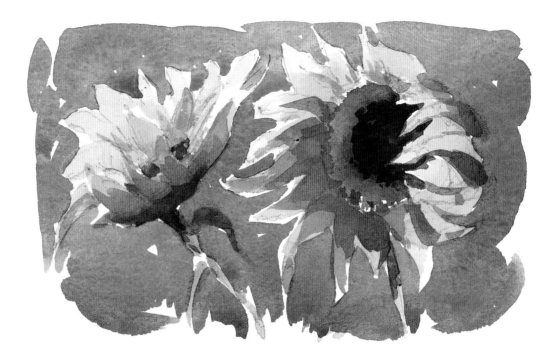

▶ Sunflowers
11 × 18 cm (4½ × 7 in)
Here I used Cadmium Yellow, Alizarin Crimson and French Ultramarine on Bockingford Not paper, beginning with the yellow petals. The dark centres were painted using all three primary colours with little water. I left white unpainted paper showing in some areas, which gives extra life to a watercolour.

Therefore, the most important rule when you are mixing colours is to put the predominant colour that you are trying to create into the palette first (with water). For example, if you wanted a bright yellowy green, you would put yellow into the palette first, then add small amounts of blue until you had mixed the green that you wanted. In this book, the first colour I specify is usually the predominant colour of the mix, with other colours added in smaller amounts.

It isn't necessary to get the colour perfect. Practise mixing colours indoors, finding the colour of a cushion, an armchair, a piece of wallpaper, and so forth. Use any paper, even copier paper or the back of some old wallpaper – you're not painting a masterpiece, you are mixing colours and practising for a masterpiece!

QUICK TIP

Use plenty of water when mixing your pigments to keep colours transparent. Too little water can make them look muddy.

◀ **Evening Sky**
10 × 18 cm (4 × 7 in)
On Bockingford Not paper, I started the sky with French Ultramarine, adding Alizarin Crimson towards the horizon. The sea was French Ultramarine, and the headland was painted once that was dry.

▼ Learning to paint a perfect flat wash is just a matter of following the basic principles and practising until it comes easily.

Watercolour washes

The term 'wash' simply means an area of paint applied to a watercolour painting – it can be as small as a 2.5 cm (1 in) square or the size of your painting. In its most perfect form, it is an area of colour that is equal in tone throughout with no blemishes.

The secret of producing a good flat wash is to use plenty of water and not to allow the wash to dry as you work it. Start at the top on dry paper and take a large brush, fully loaded, from left to right. Start on the left again, picking up the reservoir of paint left by the first stroke, work to the right and continue in this way to the bottom. The paper must be tilted slightly to allow the paint to run slowly down. You can add in different colours as you go. For a graduated wash, make the colour paler by adding water to the paint in your palette as you work down.

Rough washes

Most of the time you don't need to achieve a pristine wash – in fact a wash with blemishes and tone and colour changes gives life and movement to a sketch. From a practical point of view, having to work quickly outdoors does not allow for carefully laying a perfect wash and you will sometimes have to paint on top of a wash before it is perfectly dry, which will disturb any perfection you have managed to achieve. But remember, however you paint your sketches you must use plenty of water to keep your paintings fluid and simple.

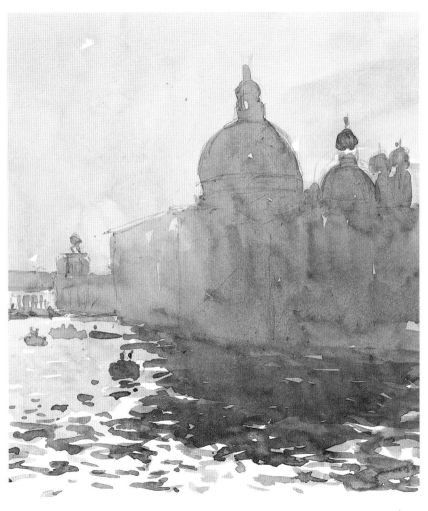

▶ **The Grand Canal, Venice**
(detail)
This painting was done on location in about 20 minutes, and consists largely of rough washes.

QUICK TIP

Before beginning a large wash, make sure you have plenty of colour mixed to avoid running out partway through the wash.

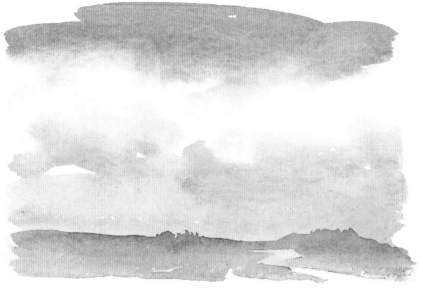

◄ **Cloudy Sky**
11 × 17 cm (4 ½ × 6 ½ in)
I painted the sky wet-on-wet on Bockingford Not. Once it was dry I painted the hills. I put in the fields while the hills were still wet.

▼ The paper was wetted first, then the colours were dropped in. The technique did the rest.

Wet-on-wet

Laying a second application of paint while the first one is still very wet allows the colours to merge, giving a diffuse effect. It is difficult to control the results, but experience will help. Wet-on-wet is a great technique for painting cloudy skies – look at the one I did above. When you paint wet-on-wet it is impossible to get a crisp edge. The only way this can be done is either on dry paper or on a dry painted area.

Painting up to wet areas

When you want to paint one wet colour area next to another and you don't want them to merge together, leave a thin unpainted paper line between them. However, allow them to merge together in places, or the sketch may look as if it was painted in separate units. You will find that you need to use this technique quite often when painting quickly outside because the paint will not have dried before you want to carry on working.

Wet-on-dry

In this technique, the second application of paint is made only when the first is dry. Painting wet-on-dry gives crisp, clean edges.

Painting shadows

As a rule of thumb, for shadows mix French Ultramarine, Alizarin Crimson and a little Yellow Ochre. Paint this mix over the colours in the area you wish to be shadowed. The colours beneath will show through, but darker, giving the illusion of shadows.

▶ Here two lines of shadow colour were painted onto the underlying colours. This also shows how painting on top of dry paint gives crisp edges.

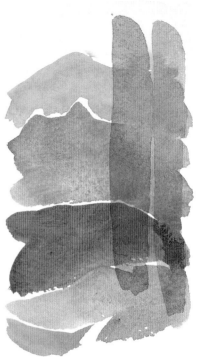

◀ **Telegraph Poles, Japan**
15 × 23 cm (6 × 9 in)
In this sketch I painted up to wet areas, leaving a thin line between colours. I painted in shadows when the colours underneath were dry.

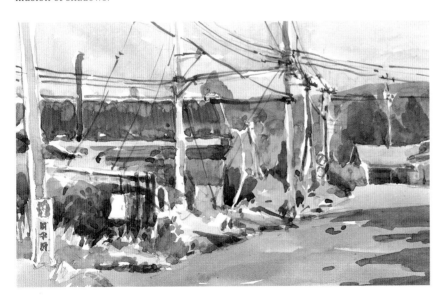

Dry-brush technique

The dry-brush technique is good for suggesting texture and for leaving white paper showing where you want to suggest light. With your brush almost dry, drag it across your paper. It will leave flecks of unpainted paper, especially on Rough surface paper.

Sometimes you will have a fully loaded brush to start an area of your sketch but you will want to progress smoothly into the dry-brush technique. Your brush of course is not dry, but you can get a dry-brush effect by pressing down hard on to the bristles where they come out of the ferrule (the metal end of the brush handle) and dragging the brush along. This needs practice but is well worth the time spent.

You will develop your own brush strokes as you progress. Don't be afraid to use them, as they will be natural to your way of working. There is no such thing as an incorrect brush stroke – if it works, it's good.

▲ Dry-brush stroke on cartridge drawing paper.

▲ Dry-brush stroke on Bockingford Not watercolour paper.

▲ Dry-brush stroke on Bockingford Rough watercolour paper.

▲ Dry-brush stroke with a fully loaded brush on Bockingford Not watercolour paper.

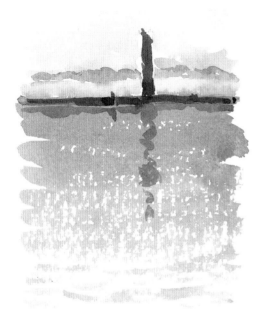

▲ Reflections
14 × 11 cm (5½ × 4½ in)
The reflection of the
post immediately
indicates the
presence of water,
and using the
dry-brush technique
to leave flecks of
white paper suggests
light upon the water.

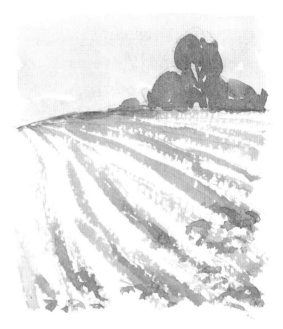

▲ Ploughed Field
12.5 × 11 cm (5 × 4½ in)
Here the dry-brush
technique suggests
the broken earth of a
ploughed field. The
lines become thinner
towards the trees to
indicate distance.

QUICK OVERVIEW

☐ You can mix all the colours you need
from red, yellow and blue.

☐ Start your colour mixing with the
predominant colour.

☐ The secret of a good wash is to use
plenty of water.

☐ Use the dry-brush technique for
texture and to leave flecks of white paper.

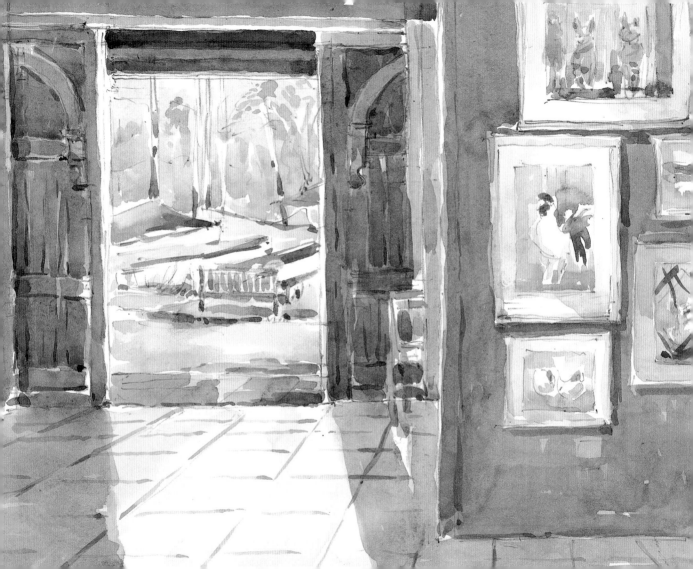

SKETCHING INDOORS

If you are a beginner, the best place to start sketching is indoors – you won't be concerned about the weather or strangers watching you and you won't have to carry your equipment to a suitable location. You can easily find enough to sketch in your own home, and if you set up a still life subject you will be in complete control of the subject, the lighting, and your own comfort.

If you want to sketch some outdoor scenes you can work from your photographs (see page 88), which is ideal if you don't have time to go out and about – if you have only 30 minutes to spare you can devote it all to sketching indoors rather than losing time travelling.

◄ **Boathouse Gallery**
20 × 28 cm (8 × 11 in)
In sketches of interiors, an open door or a window will generally be the brightest area.

Sketching still life

You should be more familiar now with using a pencil and the marks you can make with it, and still life is an ideal subject for practising quick sketching techniques. The exercises on this page were all done with a 2B pencil on cartridge paper and illustrate objects that you can easily find indoors. Copy mine first and then choose some objects in your own home. Remember that you can use an eraser for rubbing out, but do keep your construction lines in as this helps to give the object stability and life. Be bold and positive. If you just draw an outline your sketch will look weak and lifeless, so add shading to show form.

▶ **Cylindrical shapes**
This cylinder has to be drawn much more carefully. Notice how I have drawn many lines to get the top and bottom looking accurate. Each is a circle seen at an angle, called an ellipse (oval). I used the cylinder as a starting point to sketch the mug.

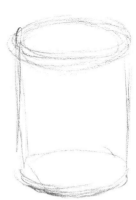

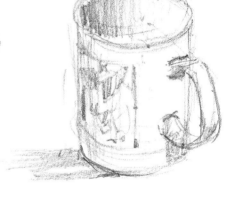

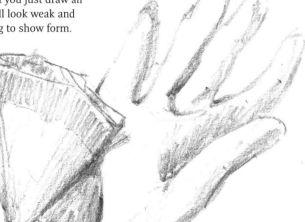

▶ **Rubber Glove**
A good thing about drawing a rubber glove is that even if the drawing were not absolutely accurate it would still look like a rubber glove!

▷ Apple
I put in plenty of construction lines on the apple and sketched in the background with free line shading.

▽ Sunflower
The dark centre of the sunflower helps to give it a three-dimensional look.

▽ Potted Plant
Again there are ellipses at the top and bottom of this cylindrical shape. You can see the construction lines inside the pot – don't be afraid of leaving drawn lines in a pencil sketch.

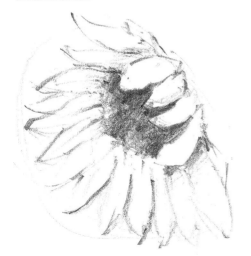

▲ Strawberry
The strawberry is drawn very freely, with a cast shadow to establish it on a surface.

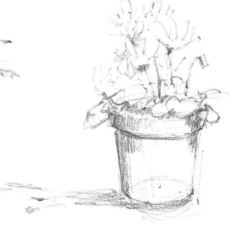

Working loosely

Many beginners tend to paint tightly (very carefully). However, you must learn to work more loosely, and your state of mind is the most important thing here. Your aim at the outset should be to make your picture loose and you must try to keep that at the front of your mind with every brush stroke you make.

Different approaches

There are several ways to practise working loosely. You can draw very few pencil lines, showing only the most important shapes, so that when you paint it is the brush strokes that are making the shapes and you are not trying to paint up to your pencil lines to keep everything neat and clean. Another, more difficult, way is to do no drawing and start straight in with your paintbrush and colours only.

A third way of working loosely is to limit yourself to just three minutes to make a pencil sketch of your subject. This is excellent for teaching you what to leave out as you will only have time to put in the important features. Your pencil will have to skate along and it doesn't matter if your drawing doesn't look good – you will be learning by doing.

Look at the detail of *Primroses* to see just how free your brush strokes can be

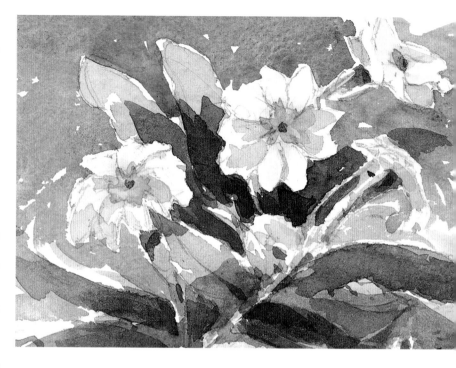

and how leaving little accidental or deliberate flecks of white unpainted paper helps a watercolour sketch. Practise by using mine as a guide and try to keep your brush strokes free and loose. Start with the petals, then the leaves; put in the flower centres and the shadows, and finally paint the background.

▲ **Primroses**
9 × 12 cm (3½ × 5 in)
I drew the flowers and leaves with a 2B pencil on Bockingford Not and then painted with a No. 6 brush, using Cadmium Yellow Pale, Hooker's Green Dark, Alizarin Crimson and French Ultramarine. When I worked the background colour up to the flowers I left some white edges against the petals.

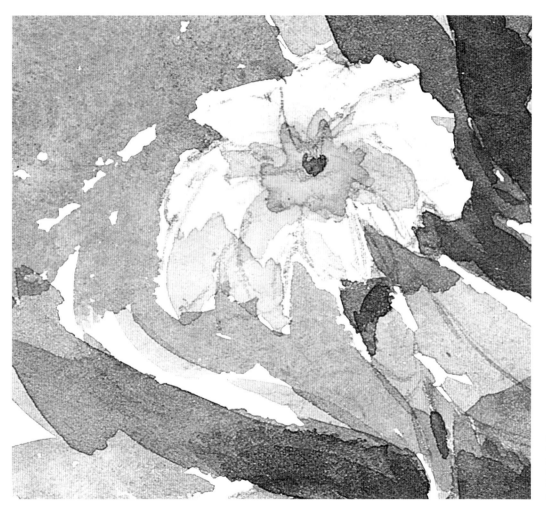

◄ This detail of *Primroses* is shown more than twice the actual size so you can see the loose brush strokes more easily.

Washing out

The term 'washing out' usually refers to the technique of lifting out paint with a damp brush. However, there is another form of washing out and it's very useful with a painting that is not going right – perhaps the colours might be too strong or the darks too dark. Just put the painting in the sink and let the water run on it until it is completely soaked, rubbing it in downward strokes with your fingers. The result will be a lovely delicate image where some of the colours have run together, but your shapes remain. Once it is dry you can add to it if you wish.

Washing out produces a different effect to painting wet-on-wet, where your edges would disappear altogether. With this technique your edges and forms are still there, but the water has simply taken everything down in tone. Rather than throw away a painting that has gone wrong, try this technique and you may find you have got something lovely – happy accidents occur and can be very exciting.

▶ **Rose**
For this simple study of a rose I painted the leaves with Hooker's Green Dark and Cadmium Yellow Pale, then added a little Alizarin Crimson for the stem. The petals were a mix of Alizarin Crimson, Cadmium Red and Yellow Ochre, with unpainted white edges in order to separate them.

▼ **Rose**
9 × 15 cm (3½ × 6 in)
I put in a background of French Ultramarine mixed with Hooker's Green Dark and Alizarin Crimson, making flowing leaf-like edges with my brush strokes. Next I washed out the whole painting. Once it was dry I added a little more detail to the flower and leaves.

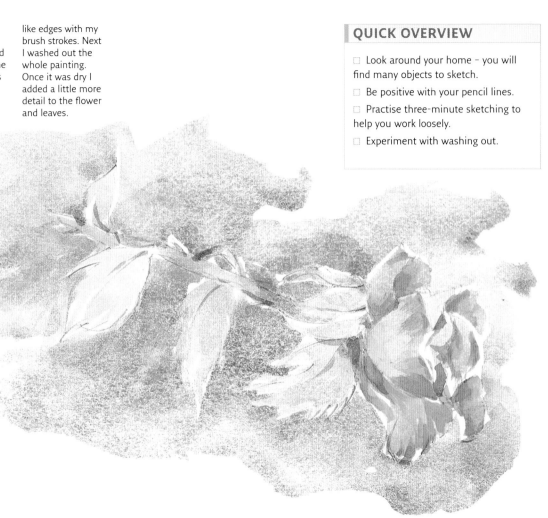

Planning your still life

The most traditional indoor subject is a still life which is set up with different household objects. You can create your own scene to paint, and from that one scene, moving round it, you can make many different sketches.

Making the most of the subject
When you set up your still life for this project, make sure that none of the objects will be wanted by a member of the family and choose a table that isn't always in use so that you have plenty of time to consider it undisturbed. Try to have only one directional light source on the subject as this helps to give strong light and shade.

Look at your still life from many angles and use your creative imagination to make an ordinary subject more visually exciting. The four pencil sketches here show different views of the still life in the watercolour sketch opposite, illustrating

how many aspects can be found from the same subject. Another method, if you have a digital camera, is to work around your still life taking many photographs – you will soon see just what you can get out of one still life. If the still life is complicated, don't include the drawing in the 30 minutes – only the painting time.

These three pencil drawings show how I moved my position and found very different views of the same still life.

▶ **Still Life**
17 × 15 cm (6½ × 6 in)
After drawing with my 2B pencil on Bockingford Not, I painted this still life with my No. 6 brush, using all the seven colours in my palette. The cast shadows are essential to place it on the surface.

▼ This was the fourth drawing and I liked it more than the other three as the orange and teapot are so powerful – the other two items just help the composition.

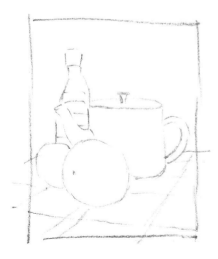

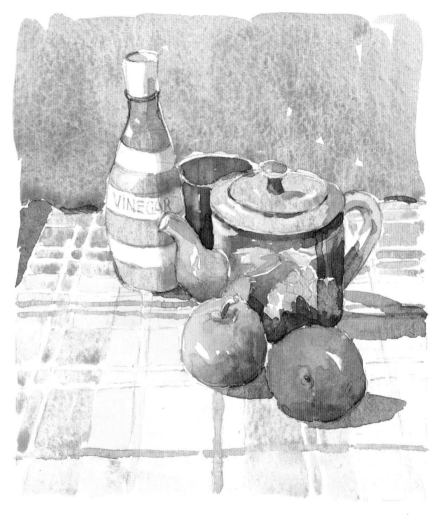

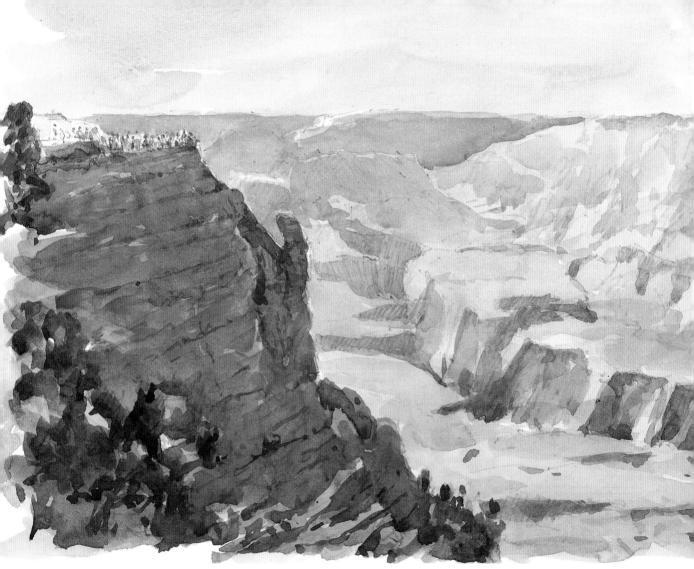

SIMPLIFYING YOUR SUBJECT

This is perhaps one of the most important chapters in the book. Just think: if you couldn't simplify a scene that was in front of you – say, a landscape – you would not be able to sketch or paint it at all. Simplifying is something you learn to do as you look at the subject – a non-painter sees everything, but an artist sees only what is important to his or her sketch.

Sketching in 30 minutes soon teaches you to simplify, but for a real challenge three-minute exercises are great. Some are included at the end of this chapter and the more you do, the more practised you will become at drawing or painting only the essentials.

◀ **The Grand Canyon, America**
20 × 28 cm (8 × 11 in)
This is a very complicated view, but simple brushstrokes were enough to suggest whole cliffsides.

20 × 28 cm (8 × 11 in)
The figures are
simply white shapes
or shaded black
silhouettes and the
boat is untouched
except for the
outline. I did this
sketch in about six
minutes, as the boat
was moving.

Keeping it simple

If you are sketching a landscape with a
field of corn in the foreground, for
example, you clearly can't include every
ear of corn, the stems, the leaves, the
earth with stones and so on – nor indeed
would it make a successful picture.
Therefore, you have to show your field of
corn with one or two brush strokes or
pencil strokes.

One way of eliminating detail is to screw
your eyes up – you will see only the darkest
and the lightest areas, and the middle
tones that have a lot of detail in them will
disappear. If you try this you will find it
just as helpful whether you are indoors
or outdoors. You must also train yourself
to exclude irrelevant detail from your
sketches. When you are painting, use a
large brush to stop you 'detail hunting',
and in pencil sketching, work with a soft
pencil. Using the long pencil hold will
make it difficult to put too much detail in.

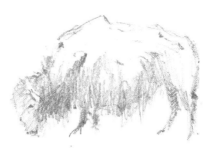

▶ Two Bison
I sketched these
with strong darks
and highlights.
The shading is in
downward strokes
to represent the
animals' fur.

▶ Performing Dogs
You can almost
count the few pencil
strokes that I used
for these dogs.

▶ Daisy
9 × 10 cm (3½ × 4 in)
For this very quick
study I painted
the background
first, wet-on-wet,
and then put in
the flower.

Complicated scenes

Don't be put off sketching because the scene is too complicated – just take a little time to work out how to simplify it. In an urban scene such as the painting shown here, the background buildings need only be washes of colour as they are not of any real importance to what you are painting. For those in the middle distance, putting in a few windows with simple strokes is all you need to do. The same applies to landscapes – mountains and forests in the background or middle distance need only be suggested enough for the viewer to be able to understand what they are.

Defining the foreground

If you have got a lot of people, animals, boats and so forth in the foreground, make sure that the most important one is readable, then you can sketch the rest loosely. If just one boat is identifiable, for example, the viewer's imagination will accept the rest as boats, even if you have painted them very freely. Surfaces such as streets, grass and water can be shown with just a few quick brush or pencil strokes.

Perhaps the most important aspect of painting a complicated scene is to be inspired by it. If you are not, you will find it hard work and soon lose interest.

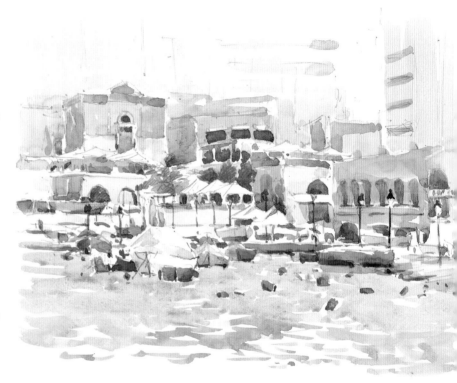

▲ **Spinola Bay, Malta**
20 × 28 cm (8 × 11 in)
Because of the complicated drawing, this sketch took 40 minutes. The weather was extremely hot, so I was helped by the paint drying quickly.

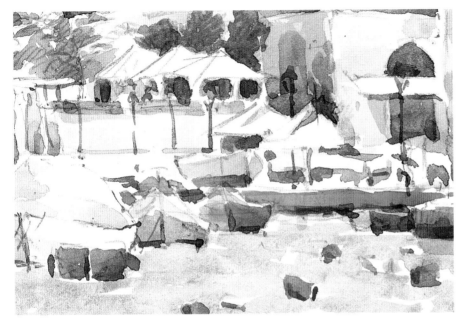

This detail from *Spinola Bay, Malta* shows that the brush strokes are not neat and precise, but they are still painted carefully.

The foreground water in *Spinola Bay, Malta* was painted in one wash, leaving white paper to give the impression of sunlight on shallow waves.

Moving objects

To sketch a moving subject, you really must simplify or your subject will have gone while you are still thinking about it! There is no secret formula for this except of course practice, which gives experience. While you are still practising, sketch slow-moving subjects such as an aeroplane taxiing to the runway, a boat slowly leaving harbour or a tractor ploughing a field.

Remember that this is not an exercise to practise detail – on the contrary, it is an exercise to learn how not to be obsessed with detail and to know what to leave out. Try sketching in pencil from the television. You will probably find it hard at first but it gets easier and is very enjoyable. I once did a lot of pencil sketches of dogs during a sheepdog trials programme, taping it as well so that I had more opportunities to sketch from the tape later.

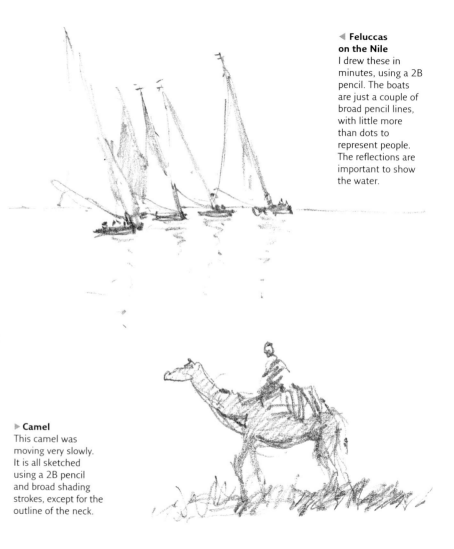

◀ **Feluccas on the Nile**
I drew these in minutes, using a 2B pencil. The boats are just a couple of broad pencil lines, with little more than dots to represent people. The reflections are important to show the water.

▶ **Camel**
This camel was moving very slowly. It is all sketched using a 2B pencil and broad shading strokes, except for the outline of the neck.

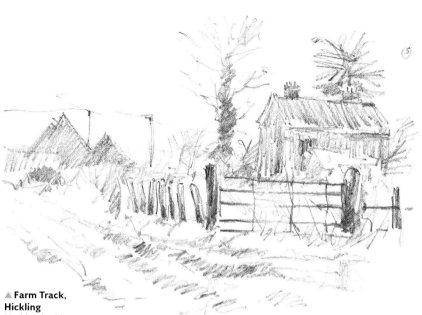

▲ Farm Track, Hickling
Nothing in this sketch was moving, but I was, as the weather was very cold and snowy and you can't draw with gloves on! I had to sketch it very quickly, so I used a 6B pencil to help me simplify the scene.

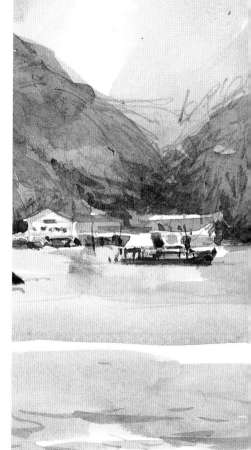

▶ Lake Kawaguchiko, Japan
(detail)
This is a detail from an A4 size sketch. I saw the black boat coming and left a space for it, then painted it with a few brush strokes when it moved through my sketch area.

Three-minute exercises

Three-minute exercises are fun to do and very important for teaching you to simplify. It may sound daunting at first, but you will find that once you have accepted the time limit your pencil will dance over the sketchbook and you will enjoy the experience.

Birds are a wonderful subject for a three-minute sketch. Start by copying my sketches – the ones on this page were done with a 2B pencil, while those on the opposite page were drawn with a 6B pencil. Then copy from photographs as they will show you the form and movement of birds, but you must remember the three-minute limit and draw them quickly. This will help you when you sketch them from life. The object is to get the shape and character of the birds. You will only get minutes or less when you do them from life and this is where a 6B pencil helps. This exercise will help you to concentrate, to observe and to work fast, and above all to simplify your work. I know it's a challenge, as I've been through it – good luck!

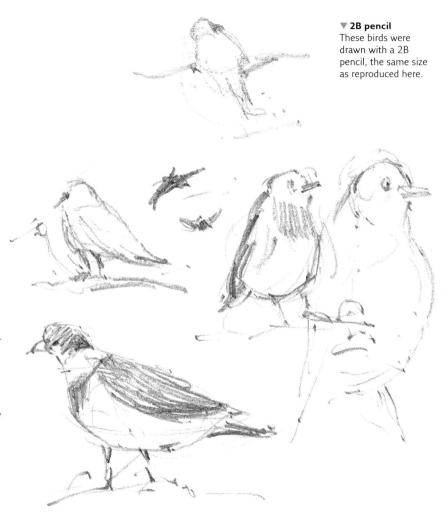

▼ **2B pencil**
These birds were drawn with a 2B pencil, the same size as reproduced here.

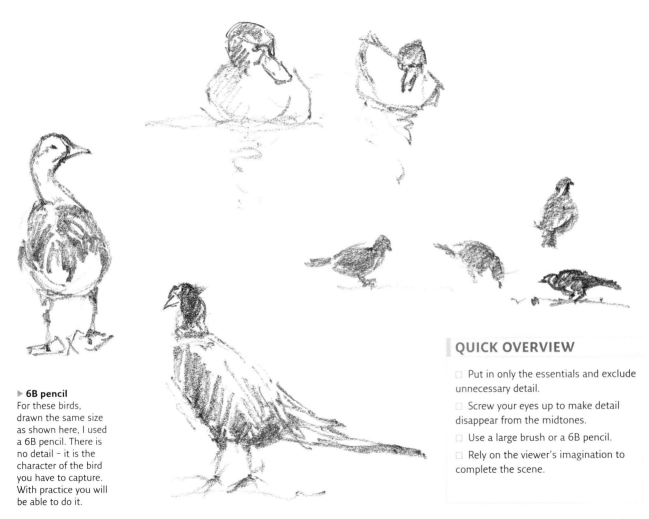

▶ 6B pencil
For these birds, drawn the same size as shown here, I used a 6B pencil. There is no detail – it is the character of the bird you have to capture. With practice you will be able to do it.

QUICK OVERVIEW

☐ Put in only the essentials and exclude unnecessary detail.

☐ Screw your eyes up to make detail disappear from the midtones.

☐ Use a large brush or a 6B pencil.

☐ Rely on the viewer's imagination to complete the scene.

Simplifying your subject

Showing form with your pencil, using directional lines and shading, makes colouring very simple as the pencil shows through the watercolour and gives the illusion of three dimensions. This is very important when sketching.

MATERIALS USED
2B pencil
Nos 6 and 10 round
 brushes
Cartridge paper
Alizarin Crimson
Coeruleum
French Ultramarine
Yellow Ochre

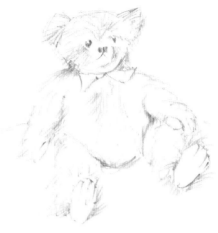

1 Draw the bear using your 2B pencil. Suggest the furry material by shading, drawing the lines in the direction of the hairs. Shade darker areas to show form, for example the bear's neck, arms and legs.

2 With your No.10 brush, mix three separate washes of Yellow Ochre, Alizarin Crimson and French Ultramarine. Start at the head and work down, adding different colours to your wash as you work (see page 24). The brush strokes must follow the direction of your pencil strokes, which will show through the watercolour.

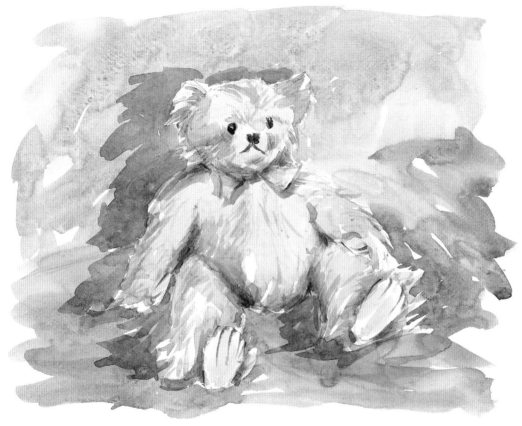

3 Now paint the tie with Coeruleum, using your No. 6 brush. Next add the feet, eyes and nose. Still using the original bear colours, but a little darker, add some more 'fur' modelling to the bear. When it is dry, with a wash of Coeruleum, French Ultramarine, Alizarin Crimson and a little Yellow Ochre, paint the background with your No. 10 brush. Do this very freely, with plenty of movement in your brush strokes. Finally, when this is dry, paint in the shadow.

◀ **Teddy Bear**
20 × 25 cm (8 × 10 in)

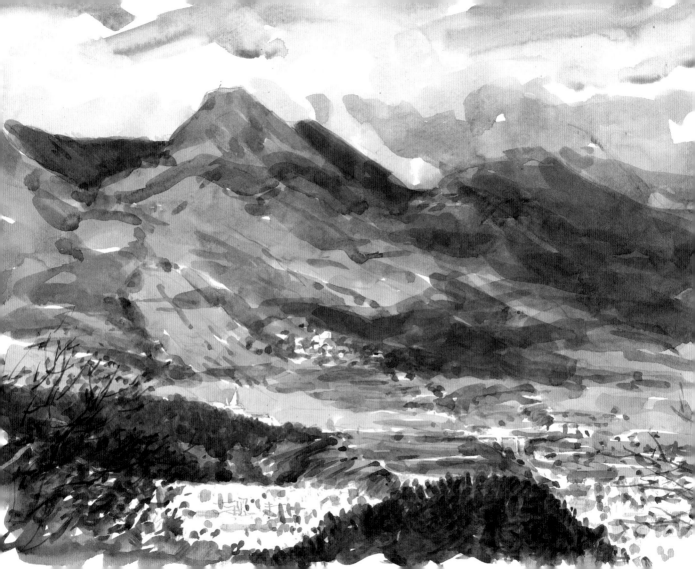

SKETCHING OUTDOORS

I have had some **of my happiest** moments sketching outdoors. What can be **better for an artist**, whether beginner or professional, than sitting in **the countryside** watching the clouds drift by, their shadows making **wonderful patterns** on the distant landscape? The sounds of birdsong, **rustling leaves** and maybe a stream or river add to the sensory **enjoyment and in**spire all kinds of subjects for an outdoor sketch.

You don't need **to carry a lot of** heavy equipment around with you, and working **outdoors gives you** the chance to try to conjure up the atmosphere of **the day as well as** the physical features of the scene.

◀ **Looking Over Kamoro City, Japan**
28 × 40 cm (11 × 16 in)
This was a very big subject, but simplifying the city made it quick to sketch and gave prominence to the power of the mountains.

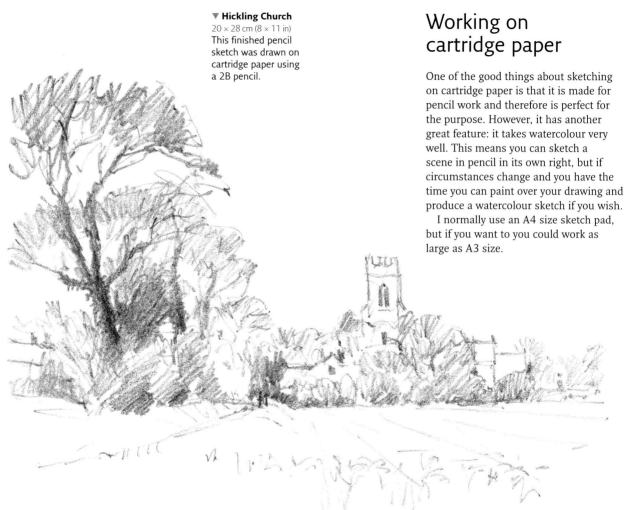

▼ Hickling Church
20 × 28 cm (8 × 11 in)
This finished pencil
sketch was drawn on
cartridge paper using
a 2B pencil.

Working on cartridge paper

One of the good things about sketching on cartridge paper is that it is made for pencil work and therefore is perfect for the purpose. However, it has another great feature: it takes watercolour very well. This means you can sketch a scene in pencil in its own right, but if circumstances change and you have the time you can paint over your drawing and produce a watercolour sketch if you wish.

I normally use an A4 size sketch pad, but if you want to you could work as large as A3 size.

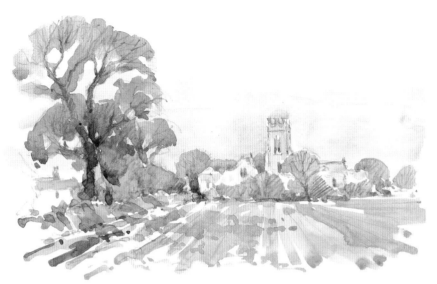

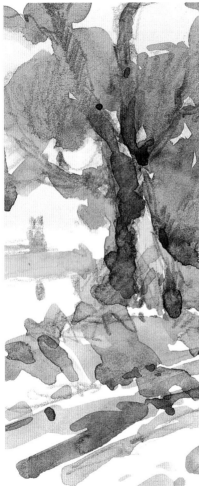

▲ Hickling Church
20 × 28 cm (8 × 11 in)
I sketched the same subject again on cartridge paper to show how you can paint over a pencil sketch. The brush strokes of the ploughed field lead to the church, giving a sense of recession and showing the flatness of the field. The tree foliage was painted wet-on-wet, allowing colours to mix and merge.

▶ This detail of *Hickling Church*, reproduced actual size, shows how simply the house, the hedge and the tree were painted. I used my No. 10 round brush for most of this sketch.

Sketching distance

In a landscape subject, where you may be looking far into the distance, you will want to bring that sense of recession to your sketch. In nature, atmospheric haze turns colours in the distance cooler (which is to say bluer) and paler, while warm colours (reds and oranges) are strongest in the foreground. Take advantage of this phenomenon, which is called aerial perspective, in your painting to give depth. For instance, if you paint a red building in the distance, tone it down accordingly so that it doesn't jump forward in the picture. Take care to make all colours and tones paler as they recede into the distance.

Definition and detail are also lost in the distance, so don't be tempted to put them in! A tree in the middle distance with more detail than one in the foreground will confuse the eye and lose the recession you are trying to show.

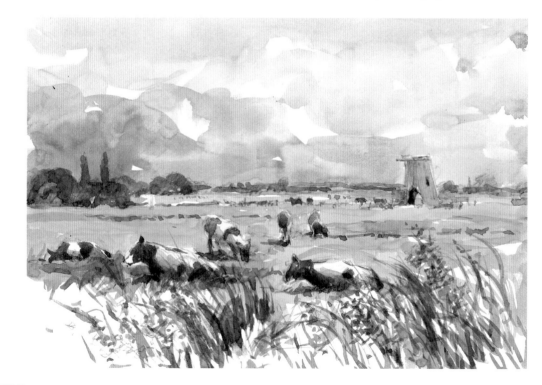

▶ **Across the Marshes**
20 × 28 cm (8 × 11 in)
In this landscape the old windmill was built of red brick, but I had to tone down its colour so that it didn't jump forward into the foreground.

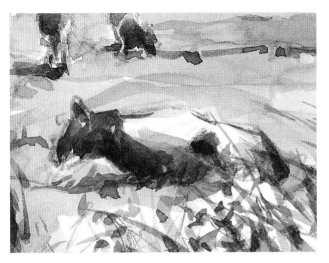

◄ In this detail of *Across the Marshes*, reproduced actual size, you can see that I have put in only the basic form of the cows.

▼ Notice how blue the distant hills of *Across the Marshes* are, with no detail visible at all.

QUICK TIP

Placing distinguishable objects in the foreground is an effective way of helping to increase the sense of recession in a sketch.

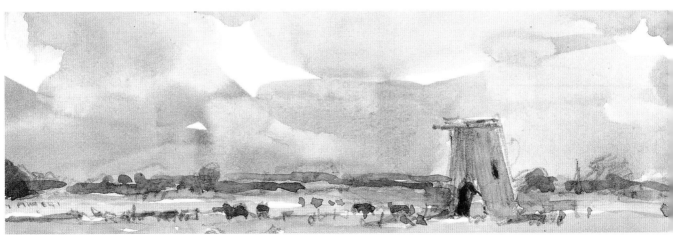

Trees in pencil

In the landscape you will nearly always find trees, so it's important to practise sketching them. Unless you are working with distant trees, always start at the bottom of the tree and draw upwards. Work in the direction that the branches are growing, too, and remember that they get thinner as you go up the tree.

It's important to make the tree trunk and the way it grows out of the ground convincing. The three main rules are:

1 Don't curve the bottom of the trunk like a pantomime tree! This doesn't occur much in nature.
2 A tree trunk is round, like the cylinder on page 32. Practise by drawing your trunks with ellipses.
3 Because the trunk is round, draw shadows on the trunk going round the tree – not straight across, or it will look flat.

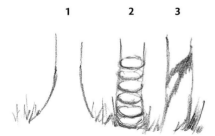

1 **2** **3**

▶ **Building and Tree**
(detail)
This sketch has a little more detail in the foreground tree and darker tones than the background. This helps to show distance and make the foreground tree prominent.

▼ **Branches**
When you are drawing branches, remember they get thinner as they grow outwards.

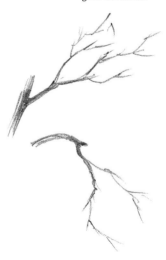

QUICK TIP

Practise sketching just one species of tree at first, either in leaf or out of leaf – this will give you confidence.

Trees in watercolour

As with other subjects, when you paint your trees do it very simply – don't overwork them. Start by painting the trunk first, then work up the tree to the smaller branches. If the tree is in leaf you can paint over the wet branches with the foliage (see *Tall Tree*, below). Leave areas where you can see through the leaves, especially with foreground trees, or they can look solid and lifeless.

When you are painting trees you will not need much pencil drawing – let the brush do the work.

▶ **Gum Tree, Australia**
20 × 9 cm (8 × 3½ in)
I painted the two trees behind the gum tree dark to make the silvery gum tree trunk stand out.

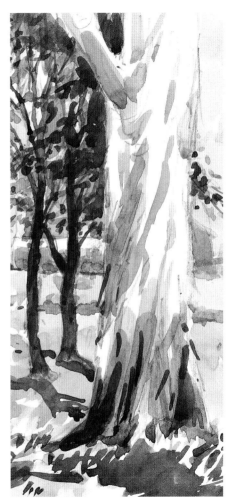

▼ **Distant Trees**
Single brush strokes are enough to show distant trees; they must be simple. With these, start at the top and work down the trunk.

▶ **Tall Tree**
12 × 10 cm (5 × 4 in)
Including the fence gives scale to this tree, painted wet-on-wet.

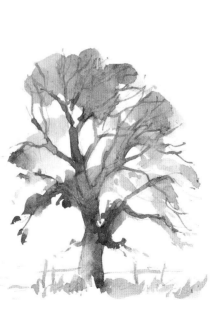

Sketching cityscapes

Compared to the calm of landscapes, there is usually a lot happening in a city scene. There are complicated structures, a bewildering amount of traffic and plenty of people either rushing to work or enjoying the leisure facilities that the city has to offer.

Concentrating on the essentials

When you are sketching a scene such as this, sit down, relax and look at it until you feel you are familiar with it, and most importantly the scale of it. Take time to draw the most dominant structures in the position you want on the paper, making them as accurate as you can. Once you get them right the rest of the sketch will be relatively easy as long as you remember to simplify everything rather than trying to describe it in detail.

This scene is very similar to the one of Spinola Bay in Malta (see page 44), but this one involves more drawing. Naturally, with a subject such as boats and windsurfers they will move in and out of your scene constantly. When you see one in a position you like, draw it. I saw the blue and white sail at the beginning of my sketch and drew it immediately, but when I was ready to paint it, it was nowhere to be seen. The blue is very important to the sketch.

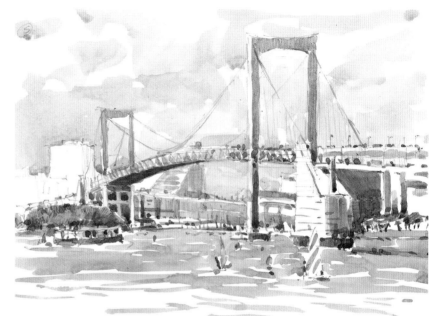

▲ **Rainbow Bridge, Tokyo Bay**
20 × 28 cm (8 × 11 in)
To keep the bridge as the main focal point I didn't paint the lefthand buildings and the ones under the bridge are simple washes without any detail.

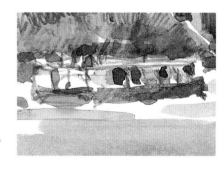

▶ This detail, shown actual size, is of one of many boats that went under the Rainbow Bridge – there was just time to sketch it in quickly.

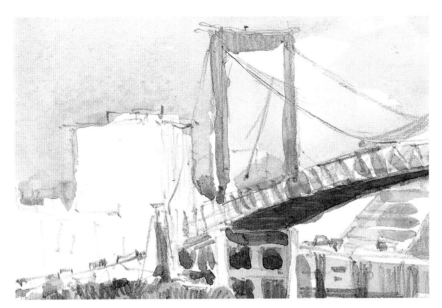

◀ In this detail of *Rainbow Bridge, Tokyo Bay*, shown actual size, the building in the background is not painted and the cables supporting the bridge are left in pencil.

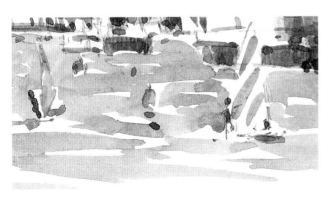

◀ I created the blue sail by leaving the shape of it unpainted and then painting three blue brush strokes over the unpainted paper. The sailor is just two paint blobs and I painted the water in one wash. This detail is shown actual size.

QUICK TIP

When you are painting cityscapes the temptation is to put in more and more detail. When you are happy with the sketch you have finished, don't fiddle with it!

Sketching birds and animals

The biggest problem with sketching animals is, of course, that they don't tend to keep still. As with the birds on page 48, start by copying photographs to learn about the animals' form, then sketch them from life.

You will often find that as soon as you start sketching your animal will move. Don't worry – it will usually return to the same position, or you will find that another animal in the group will act as a replacement. I have drawn many horses and cows that have parts belonging to other members of their group! Apart from a good sharp pencil, the secret of painting animals is the love of them, a burning desire to sketch them, and a paintbox full of patience.

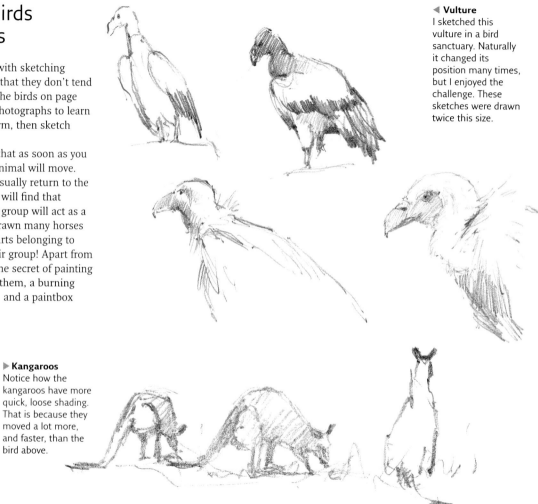

◄ **Vulture**
I sketched this vulture in a bird sanctuary. Naturally it changed its position many times, but I enjoyed the challenge. These sketches were drawn twice this size.

▶ **Kangaroos**
Notice how the kangaroos have more quick, loose shading. That is because they moved a lot more, and faster, than the bird above.

Drawing quickly

Even when you plan to paint your animals, concentrate on getting a lot of pencil sketches done quickly. Once you have done these you have plenty of time to put the colour in as of course you can still see that no matter what position the animal is in.

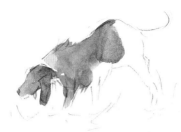

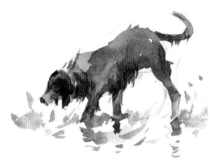

▲ **Playful Dog**
7.5 × 10 cm (3 × 4 in)
My sketches had to be very quick because this dog playing by the sea was on the move all the time. I sketched with a 2B pencil for about 15 minutes, filling two pages of my A4 sketch book, and then decided to paint one. I have used these sketches many times in studio paintings.

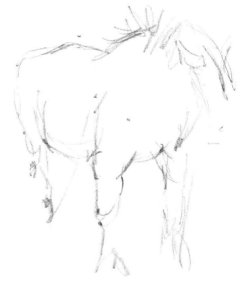

▲ **Horse**
This horse typified the problem with sketching animals. The sketch above was aborted when he got fed up and left – but he returned and stayed long enough in one position for me to sketch his head, using a 2B pencil.

Sketching people in pencil

The next four pages are about putting people into sketches rather than painting the human figure. When you have only 30 minutes to do a sketch and people may occupy only 10 per cent or less of it, they can only be suggested and usually very quickly at that.

However, you shouldn't see this as a problem as your speed will develop the more you practise. Don't try to sketch moving figures at first – begin with someone in the family sitting down or standing at the kitchen sink. Always start with the head and work down the body, trying to keep the pencil on the paper all the time. The more lines that are drawn, the more the figure will appear alive. Above all, don't try to put in detail, even if you decide to make people the entire subject of a sketch.

Try sketching the walking figures on this page, beginning with the head, continuing down the body and finally adding the legs and hat or hair. With practice, this type of sketch should only take seconds to do. Any longer and you are fiddling!

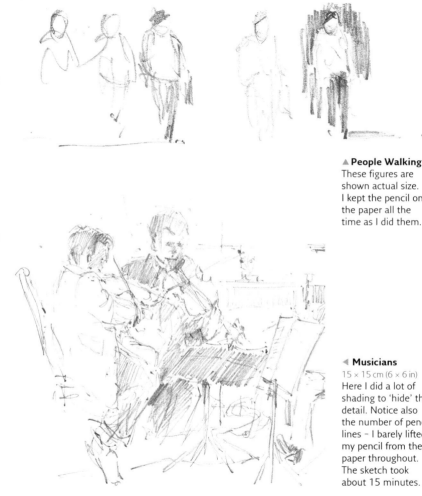

▲ **People Walking**
These figures are shown actual size. I kept the pencil on the paper all the time as I did them.

◀ **Musicians**
15 × 15 cm (6 × 6 in)
Here I did a lot of shading to 'hide' the detail. Notice also the number of pencil lines – I barely lifted my pencil from the paper throughout. The sketch took about 15 minutes.

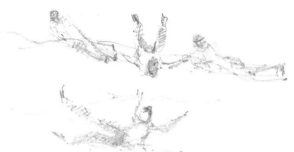

◀ **Tug of War**
These tussling
figures were
sketched very
quickly in action!

Always keep your pencil lead
long, not short and stubby. This
will give you more scope with
your pencil lines.

Multiple figures

The idea of sketching a crowd can be
daunting to a beginner, but in fact all you
need to do is to make sure that you draw
the people in front as recognizable
human figures. The remaining figures
can be even more sketchy, as you will
have created the illusion of a crowd of
people. The way to become skilled at this
is to put in plenty of practice at drawing
groups and crowds of people when you
are out and about.

▶ **Tokyo, Japan**
20 × 28 cm (8 × 11 in)
The eye sees a crowd
of people in this
sketch, but most of
them consist of only
a few lines.

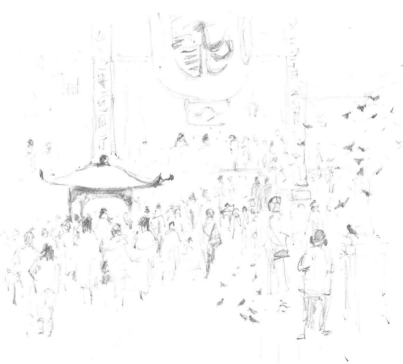

Sketching people in watercolour

Painting people in your sketches is done in just the same way as sketching with a pencil, except that of course you use your brush. You can draw them first or paint them directly. My sketches on this page are worked similarly to the pencil ones on the previous page, but done in colour. Practise painting my walking figures, starting at the top, working downwards and allowing the colours to merge together, as this gives movement in the same way that plenty of pencil lines do in a pencil sketch.

Leave white paper for your people as you paint the sketch, then add colour to them when the background is dry. When you paint the people, leave them temporarily with unpainted tops as this allows you to make the choice to have some with white tops to stand out in the finished painting.

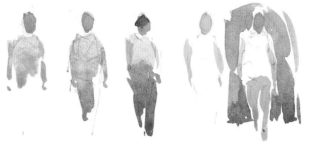

◀ **Talking to a Dog**
This quick little sketch, done outdoors, took me only about 10 minutes.

Adding figures

If you find that you need more figures after you have painted in all the background, paint them in silhouette over the dry paint as I have done on the extreme right of my sketch of the Greek temple. The two people arrived after I had painted the sky and sat on the fallen masonry. Notice too how simply a group of people can be painted in a sketch.

◀ **Walking Figures**
Using colour allowed me to sketch figures against white and dark backgrounds.

▼ **Japanese Bicycle**
(detail, actual size)
As I was working on this sketch I left a large area of unpainted paper to give me plenty of options as to where I put my figures in.

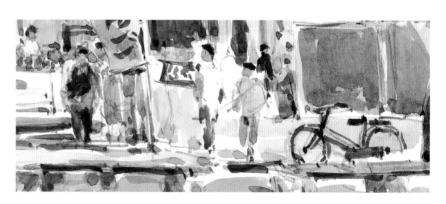

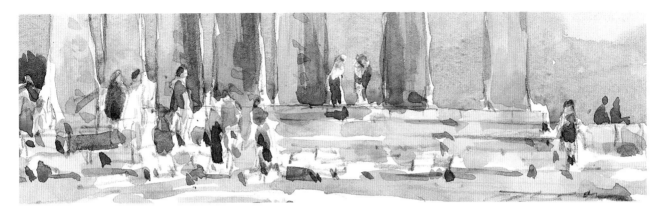

▲ People at a Greek Temple
(detail, actual size)
This detail is reproduced actual size. Here I left white paper specifically in the shapes of people – you can see a halo of white around the two figures by the pillars.

▶ Fisherman
(detail, actual size)
I left the fisherman's cap and top white so that he stood out clearly from the background.

Figures must always be painted as simply as the rest of the sketch, otherwise they will invariably look out of place in their setting.

Sketching boats

I have found that many beginners are worried about including boats in a scene as they feel they can't draw them. Naturally, they have to be drawn more accurately than a tree, for example – you can move branches around, either by accident or design, and the tree will still look fine, but if you move a mast or a cabin the boat will look wrong.

Observation, as always, is the key. Look carefully and draw what you see, not what you think you see! As usual, go for simplicity first and sketch small boats with plain-sided hulls, not clinker-built with the wooden-planked hulls as these are more difficult to draw. In the case of large liners, these are so different to small boats you can almost treat them as you would buildings.

Many boats have a curved bottom, but remember that you can only see this when they are on land – once they are afloat the water cuts straight across their sides. If the water is calm the line will be flat; on a rough sea, the line will be uneven.

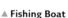

▲ **Fishing Boat**
18 × 14 cm (7 × 5½ in)
This was an information sketch, so I put quite a bit of detail in the drawing.

◄ **Yacht**
(detail)
This was done in minutes. The vertical mast and the simple reflection give the illusion of calm water.

► **The Bounty, Sydney Harbour, Australia**
20 × 28 cm (8 × 11 in)
I did this sketch in Sydney Harbour a few years ago and I was very surprised to see I did it in 15 minutes – it's on the back of the sketch! There is also another ship behind *The Bounty*, which made the scene more complicated.

Harbour scenes

In busy harbours you will find a confusing jumble of boats at all angles, and if some are sailing boats you will have masts and rigging to deal with. The only way to sketch something like this is to work very fast and keep the pencil moving on the paper. This means you won't have time to think about detail, just concentrate on general shapes. My sketch of *The Bounty* was drawn with the 3B pencil 'long hold', as this allowed me to work faster over the paper. The rigging is just a mass of pencil lines to give the illusion of multiple ropes.

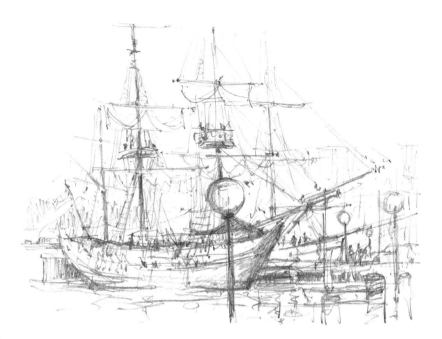

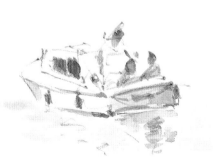

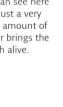

◄ **Small Boats**
5 × 12 cm (2 × 5 in)
You can see here how just a very small amount of colour brings the sketch alive.

QUICK OVERVIEW

☐ Cold and pale colours recede, while warmer and stronger colours advance.

☐ Draw and paint foreground trees starting at the bottom and working up.

☐ Focus only on the essentials in complicated urban and figure scenes.

☐ When you paint backgrounds, leave white paper for your figures.

Portraying atmosphere

Giving a sense of atmosphere is very important, even in an enjoyment sketch. This sketch of a rainy summer day is all about atmosphere, created by using the wet-on-wet technique with very watery colours and minimal detail.

MATERIALS USED

2B pencil
Nos 6 and 10 round
 brushes
Cartridge paper
Alizarin Crimson
Cadmium Red

Cadmium Yellow Pale
Coeruleum
French Ultramarine
Hooker's Green Dark
Yellow Ochre

1 With your 2B pencil, draw in the main shapes. Start with the buildings on the left and work down the street, then put in the kiosk on the right, the trees and finally the people. I didn't put any shading in the drawing, so you will be relying on your painting for the darker tones, not pencil shading, as you did with the teddy bear on pages 50–51.

2 With your No. 10 brush, work from the sky down, wet-on-wet. Use French Ultramarine and Alizarin Crimson for the sky and Yellow Ochre, Cadmium Red, Alizarin Crimson and French Ultramarine for the buildings and road; leave unpainted paper for the people. When this is dry, paint the trees with your No. 6 brush, using Hooker's Green Dark and Alizarin Crimson for the trunk and adding Cadmium Yellow Pale to the green for leaves.

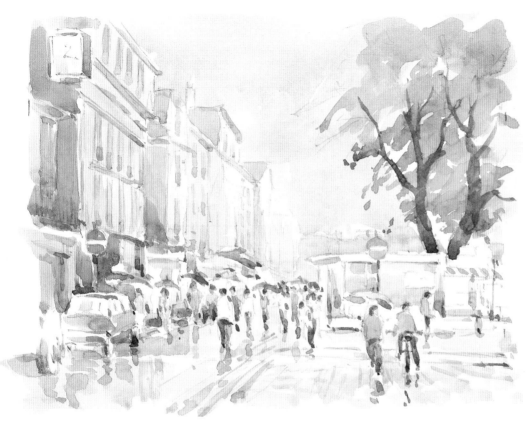

3 Use your No. 6 brush for all of this stage. Start with the buildings and, using darker tones, paint the windows and simple details. Paint the umbrellas with Coeruleum and the car with French Ultramarine. Now paint the people, the 'No entry' signs and the yellow 'No parking' lines on the road. Finally, put the reflections on the wet road. Note that all the colours are pale, as this gives the impression of a rainy day.

◀ **City Scene
in the Rain**
20 × 25 cm (8 × 10 in)

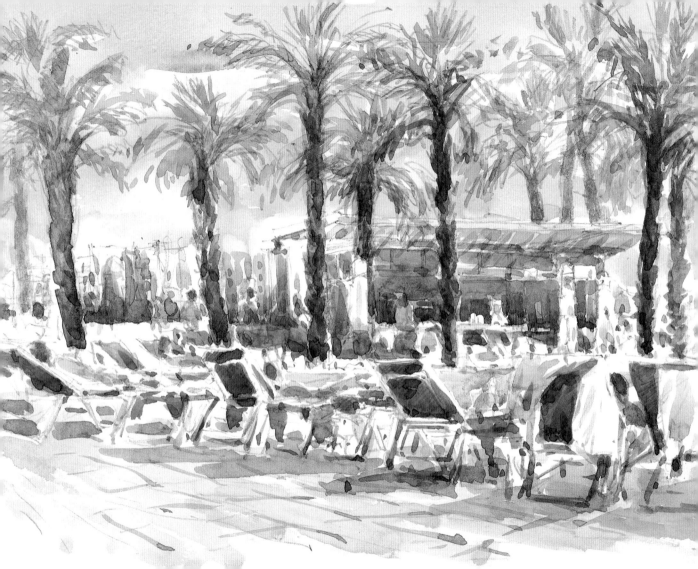

HOLIDAY SKETCHING

Perhaps the best part of sketching on holiday is the fact that you are going to bring back sketches that will become, to most people, even more evocative of your holiday than photographs. A photograph is taken in seconds, but a sketch takes 30 minutes – if you have been practising!

During those 30 minutes you will have felt the atmosphere around you, the heat that dried your paint too quickly, the boat that hit the harbour wall very hard, the children playing on the beach and so on. Long into the future, whenever you look at that sketch at home all the excitement of the trip will come flooding back.

◀ **By the Pool, Malta**
20 × 28 cm (8 × 11 in)
Even sitting by the pool on holiday there is always plenty to sketch.

Starting your holiday

The most important thing to do before you leave for your holiday is to make sure that you have all your sketching equipment. Don't go away expecting to buy some materials you need at your holiday destination – the chances are you will not be able to find an art material shop, and if you do they may not have the brand or materials you are looking for. Always check and double check!

Your equipment need only be minimal. You don't have to take an easel, a drawing board or a portable chair – there's always something to sit on, or you could stand up for a pencil sketch. For a hot country take a sun hat (very important) and always pack an umbrella; it rains almost everywhere, and the first thing you protect is your sketch, not yourself! For a cold-weather holiday take plenty of warm clothing, as you won't enjoy sketching if you are cold. If you are travelling by air, check what you can take on board in your hand luggage – which almost certainly won't include your knife for sharpening pencils.

Making the most of your time

At airports there is usually a long wait before departure, so use that time to enjoy sketching. Try to find a position where you can sketch aeroplanes with all the excitement of an airport and its surroundings. When you arrive at your holiday destination, relax and take in your new surroundings before you begin to sketch.

On holiday, sketching fast is usually important. First, you could be on the move and this restricts the time to sketch (see pages 82–83). Secondly, there can be so much that excites you that you want to sketch everything, so sketches in 30 minutes or even less are what is called for. It's worth all the practising just for the holidays!

▼ **At the Airport**
These quick airport sketches were done during the long wait for boarding to start.

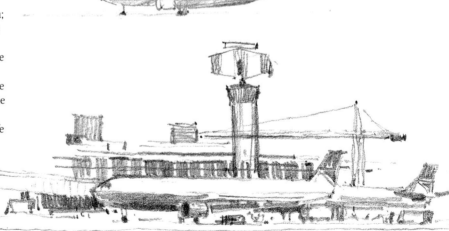

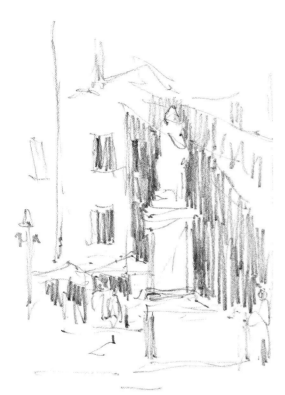

◀ **Venice**
18 × 12 cm (7 × 5 in)
I had only minutes to sketch this Venetian scene and used swift, broad, vertical pencil strokes to define the statue.

QUICK TIP

When you are travelling, space in your luggage will be at a premium. Even if you are expecting to see magnificent views, don't feel you have to pack an A3 sketchbook – you'll find an A4 one quite sufficient.

▶ **Tokyo Beach**
(detail)
This was my first watercolour sketch on arriving in Japan. Note the soft buildings and lack of detail.

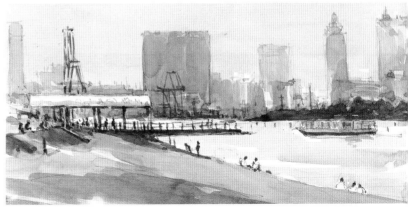

Sightseeing

When you are sightseeing, more often than not it will be in a hot climate. You must use more water than normal for painting as in very hot weather the paint will dry almost as soon as you apply it, especially if there is a warm wind – don't be afraid of overdoing it.

If the sun is hitting your paper while you are sketching you won't be able to work properly, so try to find a spot where there is some shade on the paper. Where this isn't possible, wear sunglasses – they won't affect your use of colour as you will be seeing both the view and your palette through them. Remember to look after your own welfare, too – apply sun lotion, wear a sun hat and keep your painting arm covered as it may get sunburnt. It's very easy to get so engrossed in your sketching that you forget how long you are exposing yourself to fierce sun.

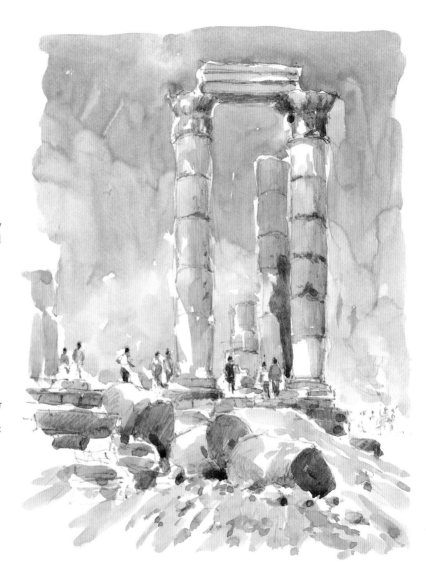

▶ **Temple of Hercules, Amman, Jordan**
28 × 20 cm (11 × 8 in)
This sketch was done with a No. 10 brush and a No. 6 brush for the figures. It was a very hot day with a strong warm wind. I used plenty of water on the sky wash, but it is blotchy because it was drying as it was applied. I painted the foreground in brush strokes leading up to the columns, which helps to give them a feeling of height.

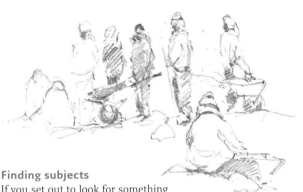

Finding subjects

If you set out to look for something specific you may be wasting precious time, so just sketch what inspires you. Sketching a famous view just because you feel you should is certainly a waste of time, as you will be working just for the sake of it. For a successful sketch, you need to be inspired and to have the feeling that you absolutely must paint it!

If you are with your family you may be restricted in both time and location, but you will always be able to find a subject to sketch, even if it is just chairs round a swimming pool – and your travelling companions won't usually mind your attention being elsewhere for just 30 minutes.

Advance planning

At tourist honeypots you will invariably find your view blocked for greater or smaller periods of time by coaches,

▲ **Workmen**
The pencil figures were on an archaeological dig in another area near the Temple of Hercules. They weren't moving much, so they gave me plenty of time to sketch them. I used a lot of shading with a 2B pencil.

groups of people listening to their tour guide, and so forth. Often it's a matter of just being patient, but observing the scene for a little while first and seeing where tourists congregate may help. It's also worth finding out the times of guided tours and coach parties.

▲ **Gondola**
28 × 20 cm (11 × 8 in)
The gondola has more careful drawing, done with a 2B pencil. It is important that shading lines go in the right direction.

At the back of the gondola they are vertical to show a flat downward plane, while short horizontal strokes give movement to the water.

A question of scale

A vast scene such as ancient ruins can be awe-inspiring, and even more so if you are about to try to sketch it. The first thing you must do is to take time to look at it and make yourself familiar with the whole aspect. For a 30-minute sketch there is no time to take detailed measurements, but try to compare the relative sizes and shapes of different areas of your sketch to help you to get each element roughly correct. Start with the main structure, and if you find you have drawn it too large, for example, simply redraw it – you can erase your first attempt if you want to, but there is no need to as your lines will all give energy to the sketch. Just carry on trying until you have got everything you want fitted into your space.

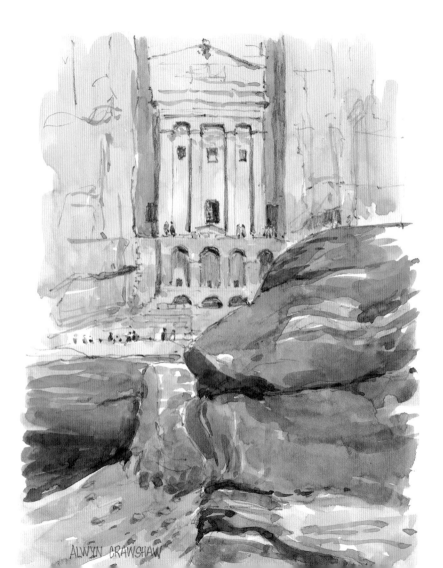

▶ **Petra, Jordan**
28 × 20 cm (11 × 8 in)
There is a big rock in the foreground of this drawing, but in itself it gives the viewer no idea of its size – it is the figures in the distance that supply that information.

ALWYN CRAWSHAW

◀ This actual-size detail of *Petra, Jordan* shows how important the figures are in describing the scale of the building.

▲ **Camels**
7.5 × 14 cm (3 × 5½ in)
In a busy tourist area there will usually be plenty of people around to give scale, but if not, seize the chance to include any figures that may pass across the scene.

Indicating size and scale

In any sketch there needs to be something to show scale. Pebbles on a beach, for example, might be huge rocks to the viewer unless you give a clue such as a crab's claw or a starfish; a tree could be of any height, so add a few fence posts, an animal or a figure. We relate to things we know, and that gives us the information we need about the size and scale in a sketch.

Pencil sketching on the move

It's amazing how many times you can find something you want to sketch while you are travelling, perhaps in a train, a boat or a car. I have even sketched from a horse-drawn carriage, doing the tourist trip around a city. You need to be in the right state of mind to do this – you must want to do it and prove to yourself you can.

A subject close to your moving vehicle will go past too quickly. One in the middle distance and going away from you is ideal, as although the subject will be getting smaller you will still be able to see it. Remember, it is even more vital not to look for detail, just for overall shape. Whatever the result you will have enjoyed the challenge and if you are doing a lot of travelling on a holiday, you will have plenty of happy sketches to remind you of it later.

Sketching on the Water
The rowing boat (shown actual size), geese and camels were all sketched from a variety of moving boats. All were captured quickly with just a few pencil strokes and shading to create form.

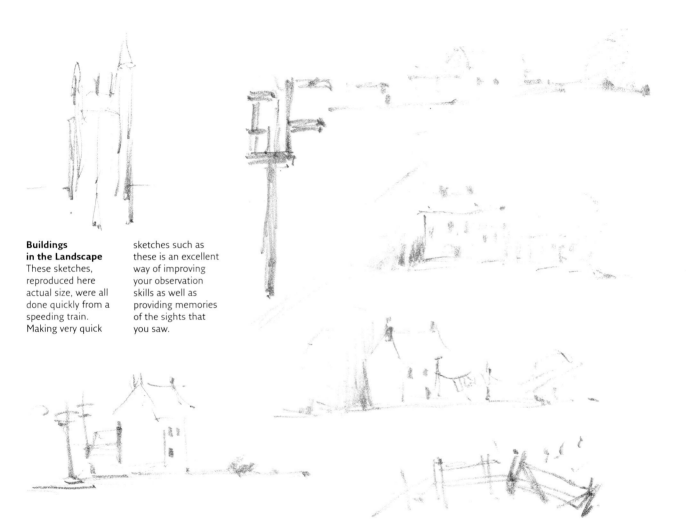

Buildings in the Landscape
These sketches, reproduced here actual size, were all done quickly from a speeding train. Making very quick sketches such as these is an excellent way of improving your observation skills as well as providing memories of the sights that you saw.

Painting on the move

To paint sketches while you are on the move you will need to have your paints and brushes in a position where they are ready for you to grab them at a moment's notice and start work. You should also be prepared to paint wet-on-wet as there won't be time for the paint to dry, so leave unpainted paper where you want clean edges so that the paint doesn't run into the adjacent colour.

The angle from which you see your subject will change, so do the drawing first, without detail, then you can paint with the colours still in view. Don't worry if you don't get exactly the right colours as you won't have time to perfect them. The sketch will still look fine if a red boat or a blue canopy, for example, aren't quite the colour they are in reality. When you are doing a sketch like this it is an impression of the scene you are trying to make, not a photographic representation.

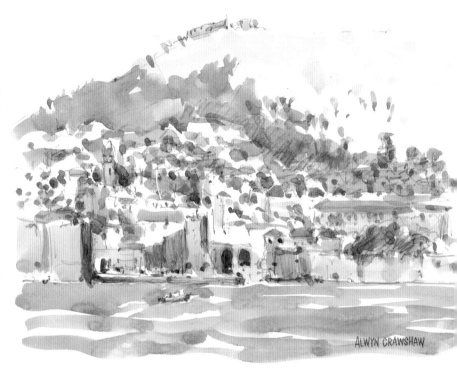

Passing a town

My sketch of Dubrovnik shown here is perhaps the most ambitious one I have done on the move. I stood on the deck of a cruise ship resting my A4 pad on the side rail as it sailed past the old port, with my paints ready. I spent about three minutes with my pencil, starting with the sea wall and the most prominent buildings, then began to paint. I used the same colour for the hill, some buildings and the sea wall, followed by the red of the roofs and then the green of the hill and trees. The sea came last and by the time I finished I was almost looking sideways at the scene, but the important shapes had been drawn so this wasn't a problem.

▲ **Dubrovnik**
20 × 28 cm (8 × 11 in)
This sketch took just under 15 minutes to do. It was impossible to be accurate, but the object was to give an impression of the town.

◄ The roofs in *Dubrovnik* were Cadmium Red, and the trees Hooker's Green Dark and Yellow Ochre. Notice how they were painted just as blobs of colour. This detail is shown actual size.

◄ This detail of *Dubrovnik* is shown actual size. I used a 2B pencil, a No. 6 brush and four colours: Cadmium Red, French Ultramarine, Hooker's Green Dark and Yellow Ochre.

QUICK OVERVIEW

☐ Always have your sketchbook and pencil with you.

☐ In very hot weather use plenty of water with your colours.

☐ When you are sketching large scenes accustom yourself to the scale before you start.

☐ Draw in people quickly as they appear in your scene – they may soon leave.

☐ For moving subjects, choose ones in the middle distance going away from you.

Sketching on holiday

This project demonstrates how you can adjust a composition when things haven't turned out as planned. This is just part of sketching outdoors, especially on holiday, and using your creativity will give you solutions for improving your sketch.

Adjusting your compositions

On holiday you may have only a short period of time to sketch a view and no matter how fast you are trying to work, coaches, boats or crowds of people may arrive and block your line of vision. There may be no chance for a second visit to the scene, so make the best of the situation by continuing to sketch with the idea of resolving any compositional problems later if you want to make a painting from the sketch at home.

The pencil sketch shown here was done from a boat. I started with the abbey ruins, then the river bank and the small boat and cruiser. Before I had finished, the yacht came past. I sketched it in, leaving the sail transparent so I didn't lose the drawing behind it, which allowed me then to try out different approaches to the composition. For this project, take out some of your holiday sketches you are not entirely happy with and see how you can improve them in a similar way.

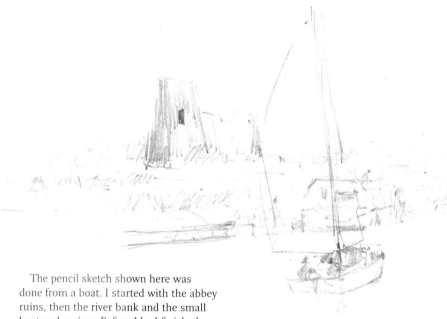

▲ **St Benet's Abbey**
This shows how I left the sail of the yacht unshaded so that I could see the bank and boat behind it.

▶ In this sketch I moved the cruiser away from the yacht.

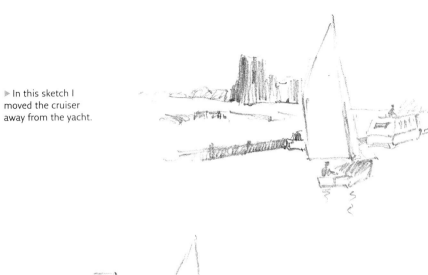

▼ **Dramatic Sky**
7.5 × 10 cm (3 × 4 in)
Here I took everything away except the yacht and painted a dramatic stormy sky behind it.

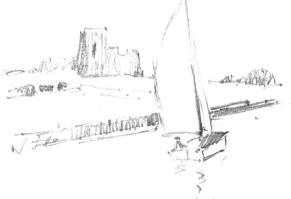

▲ Here I took out the moored boats and moved the sail away from the abbey.

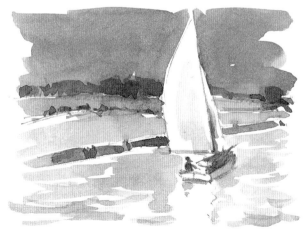

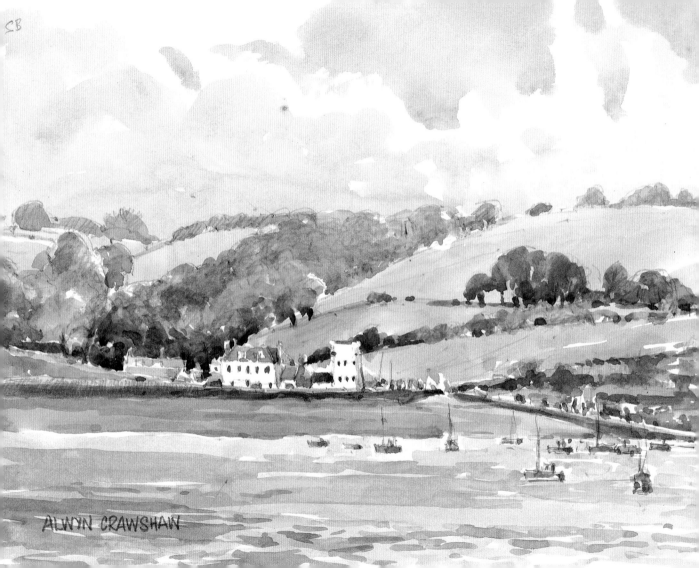

ALWYN CRAWSHAW

USING HOLIDAY PHOTOS

There are occasions when there simply isn't time to stop and sketch, especially when you are on holiday. The answer is to take a photograph. Many artists in the late 20th century were against using photographs because they believed that it took the creative thinking and drawing ability out of painting; but in the 21st century the camera has become accepted as a tool by many artists, both amateur and professional.

However, when you are working from a photograph it is important not to try to reproduce another photograph in watercolour. You must use it as a guide, a reference or an inspiration for a painting and contribute your own artistic skills.

◄ **From Archirondel Tower, Jersey**
20 x 28 cm (8 x 11 in)
To give a centre of interest, I painted the trees behind the house darker than they were in reality.

How to use photographs

The first rule to remember is that painting from photographs is not a shortcut to learning how to sketch or paint. However, they can be a great help if you use them with care, and are a particularly good source for detail.

Always try to sketch from your own photographs – you will remember the atmosphere of the occasion, and translate that into your sketch. If you are planning to make a watercolour sketch, make colour notes at the time if possible, since the colour in photographs is unreliable. Don't fall into the trap of thinking that if the colour is present in your photograph, that must be how it was in real life!

Take extra photographs to extend your scene to the right and left of what you think you want to paint so that the extra information is there if you want it. Bear in mind that the camera lens may distort the view – a telephoto lens, for example, will not only enlarge landscape features, it can flatten the distances between them.

For practice, sit in a sketching position as you would outdoors, sketchbook on your knees, then sketch from a photograph as if you were on location. Of course you are copying a two-dimensional scene, which is easier, but it's excellent practice.

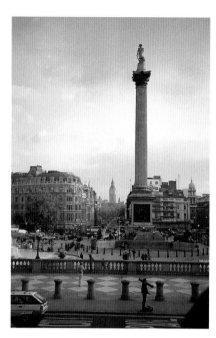

◀ I used this photograph of Nelson's Column in London as a starting point for a sketch.

▼ You can see from this detail of the sketch opposite, shown actual size, the absence of detail in the column and people around it.

▶ The figures were put in with simple brush strokes. They are reproduced here actual size.

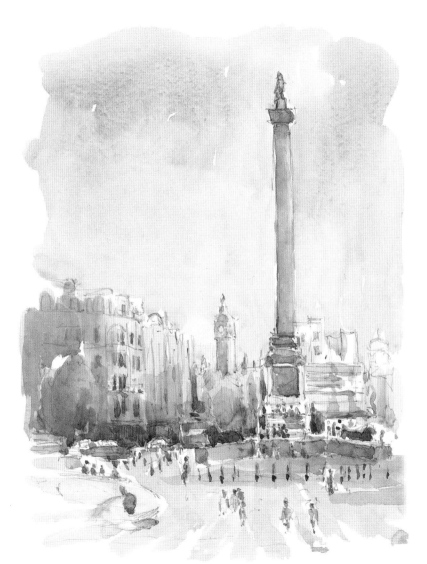

▲ Leaving pencil lines visible gives structure to a sketch.

◄ **Nelson's Column, London**
28 × 20 cm (11 × 8 in)
I drew the scene first with a 2B pencil then used a No.10 brush. I painted the sky, the buildings and the foreground wet-on-wet, leaving white paper for Nelson's Column. When that was dry, I put in the column, the lions and the figures.

Finding the centre of interest

You may be lucky enough to find the perfect composition in real life, but more often than not this won't be the case. As an artist, you are free to rearrange the landscape or cityscape, but not to alter a famous view so that it no longer looks as it should. However, you can eliminate any telegraph poles, litter bins and so forth that you couldn't manage to keep out of your photograph.

Most importantly, especially in a crowded city, you may not be able to find a way of photographing the scene so that the eye is led to what you want to make the main centre of interest. You were no doubt concentrating on it when you took the shot, but looking at the photograph you may find everything clamouring for equal attention. This isn't a problem as long as you remember to follow the rules you have already learnt.

Look at the photograph of the Grand Canal in Venice and my sketch of it. I have simplified it in the same way that I would have done if I had been painting on location. The gondola is the centre of interest, so the distant buildings have been done as a simple background, with a coloured wash and no detail. I added movement to the water to give more life to the sketch. On location I would have drawn the gondola first, as everything else would still be there long after the gondola had passed!

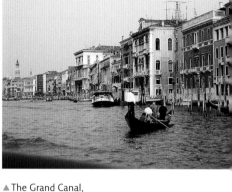

▲ The Grand Canal, Venice

▼ This detail of *Venice*, reproduced actual size, shows how the distant waterside has been simplified.

▶ I painted the gondola and its occupants with my No. 6 brush. When I painted the water I left white paper for the area of the gondolier's oar so that I could add yellow at the end.

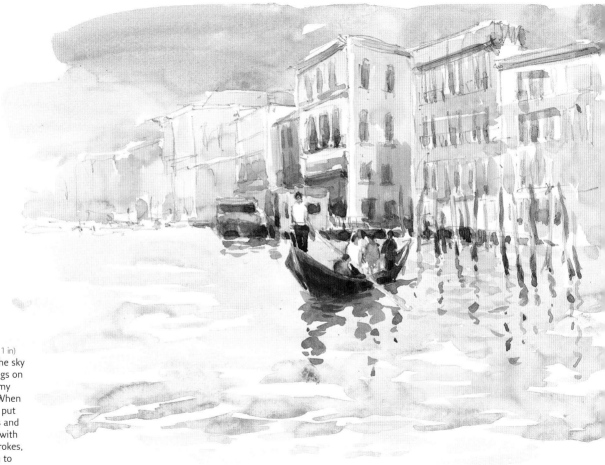

▶ Venice
20 × 28 cm (8 × 11 in)
I started with the sky and the buildings on the left, using my No. 10 brush. When they were dry I put in the windows and mooring poles with single brush strokes, then moved on to the gondola, figures and water.

Painting a landscape

If the scene in a holiday photo is complicated, take some time to observe which the important elements are before you start sketching. Remember, don't search for detail. Once you become familiar with the scene it will appear simpler and therefore easier to sketch.

MATERIALS USED

2B pencil
Nos 6 and 10 round
 brushes
Cartridge paper
Alizarin Crimson

Cadmium Red
Cadmium Yellow Pale
French Ultramarine
Hooker's Green Dark
Yellow Ochre

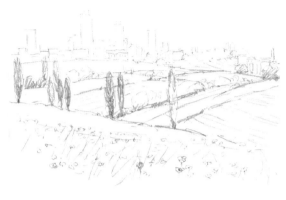

1 Using your 2B pencil, start your drawing with the buildings in the distance. Work downwards, drawing in the fields then the front field with the poppies. Finally, draw in the cypress trees and shade them in.

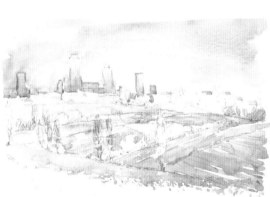

2 Paint the sky with French Ultramarine and Alizarin Crimson, using your No. 10 brush. Next, paint the large buildings with your No. 6 brush and a mix of Yellow Ochre, Alizarin Crimson and French Ultramarine. For the small buildings use very pale Yellow Ochre, and Alizarin Crimson for the roofs. Paint the fields using Hooker's Green Dark, Cadmium Yellow Pale, Yellow Ochre and Alizarin Crimson, leaving white paper for the poppies.

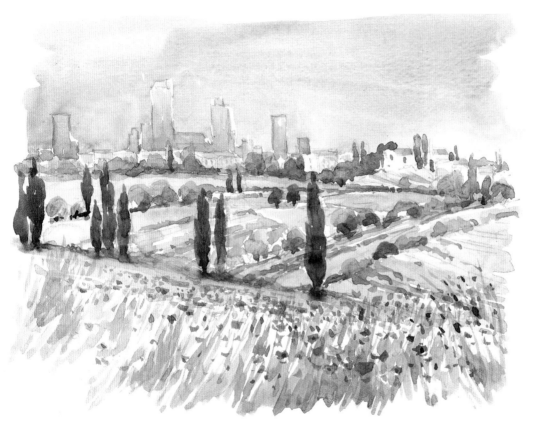

3 When everything is dry, still using your No. 6 brush but mixing darker greens, paint the hedgerows and small trees. This looks complicated, but paint the brush strokes very freely and don't try to rework them. Now, with Cadmium Red, paint brush stroke 'blobs' for the poppies. When they are dry paint the grass, using upward brush strokes. Finally, paint in the cypress trees.

◀ **Poppy Field in Tuscany**
20 × 27 cm (8 × 10½ in)

FURTHER INFORMATION

Here are some organizations or resources that you might find useful to help you to develop your painting.

Art Magazines
The Artist, Caxton House, 63/65 High Street, Tenterden, Kent TN30 6BD; tel: 01580 763673
www.painters-online.co.uk
Artists & Illustrators, 26-30 Old Church Street, London SW3 5BY; tel: 020 7349 3150
www.aimag.co.uk
International Artist, P. O. Box 4316, Braintree, Essex CM7 4QZ; tel: 01371 811345
www.artinthemaking.com
Leisure Painter, Caxton House, 63/65 High Street, Tenterden, Kent TN30 6BD; tel: 01580 763315
www.painters-online.co.uk

Art Materials
Daler-Rowney Ltd, P. O. Box 10, Bracknell, Berkshire RG12 8ST; tel: 01344 461000
www.daler-rowney.com
Jackson's Art Supplies Ltd, 1 Farleigh Place, London N16 7SX; tel: 0870 241 1849
www.jacksonsart.co.uk

T. N. Lawrence & Son Ltd, 208 Portland Road, Hove, West Sussex BN3 5QT; tel: 0845 644 3232 or 01273 260260
www.lawrence.co.uk
Winsor & Newton, Whitefriars Avenue, Wealdstone, Harrow, Middlesex HA3 5RH; tel: 020 8427 4343
www.winsornewton.com

Art Shows
Affordable Art Fair, The Affordable Art Fair Ltd, Unit 3 Heathmans Road, London SW6 4TJ; tel: 020 7371 8787
www.affordableartfair.co.uk
Art in Action, Waterperry House, Waterperry, Nr Wheatley, Oxfordshire OX33 1JZ; tel: 020 7381 3192 (for information)
www.artinaction.org.uk
Patchings Art, Craft & Design Festival, Patchings Art Centre, Patchings Farm, Oxton Road, Calverton, Nottinghamshire NG14 6NU; tel: 0115 965 3479
www.patchingsartcentre.co.uk

Art Societies
Royal Institute of Painters in Water Colours, Mall Galleries, 17 Carlton House Terrace, London SW1Y 5BD; tel: 020 7930 6844
www.mallgalleries.org.uk
Society for All Artists (SAA), P. O. Box 50, Newark, Nottinghamshire NG23 5GY; tel: 01949 844050
www.saa.co.uk

Bookclubs for Artists
Artists' Choice, P. O. Box 3, Huntingdon, Cambridgeshire PE28 0QX; tel: 01832 710201
www.artists-choice.co.uk
Painting for Pleasure, Brunel House, Newton Abbot, Devon TQ12 4BR; tel: 0870 44221223
www.readersunion.co.uk

Internet Resources
Alwyn Crawshaw: the author's website, with details of his books, DVDs and a gallery of his original paintings
www.crawshawgallery.com
Art Museum Network: the official website of the world's leading art museums
www.amn.org

Artcourses: an easy way to find part-time classes, workshops and painting holidays www.artcourses.co.uk
The Arts Guild: on-line bookclub www.artsguild.co.uk
British Arts: useful resource to help you to find information about all art-related matters www.britisharts.co.uk
British Library Net: comprehensive A-Z resource including 24-hour virtual museum/gallery www.britishlibrary.net/museums.html
Galleries: the UK's largest-circulating monthly art listings magazine www.artefact.co.uk
Galleryonthenet: provides member artists with gallery space on the internet www.galleryonthenet.org.uk
Open College of the Arts: an open-access college, offering home-study courses to students worldwide www.oca-uk.com
Painters Online: practical art site run by The Artist's Publishing Company and packed with information and inspiration for all artists www.painters-online.co.uk

WWW Virtual Library: extensive information on galleries worldwide www.comlab.ox.ac.uk/archive/other/museums/galleries.html

Videos

APV Films, 6 Alexandra Square, Chipping Norton, Oxfordshire OX7 5HL; tel: 01608 641798 www.apvfilms.com
Teaching Art, P. O. Box 50, Newark, Nottinghamshire NG23 5GY; tel: 01949 844050 www.teachingart.com

FURTHER READING

Why not have a look at other art instruction titles from Collins?

Bellamy, David, *Learn to Paint Watercolour Landscapes*
Blockley, Ann, *Learn to Paint Country Flowers in Watercolour*
Watercolour Textures
Crawshaw, Alwyn, *Alwyn Crawshaw's Ultimate Painting Course*
Alwyn Crawshaw's Watercolour Painting Course

Learn to Paint Outdoors in Watercolour
Learn to Paint Watercolours
You Can Paint Watercolour
Crawshaw, Alwyn, June Crawshaw and Trevor Waugh, *Need to Know? Watercolour*
Evans, Margaret, *30-minute Pastels*
French, Soraya, *30-minute Acrylics*
Jennings, Simon, *Collins Artist's Colour Manual*
Collins Complete Artist's Manual
King, Ian, *Gem Watercolour Tips*
Peart, Fiona, *30-minute Watercolours*
Simmonds, Jackie, *Gem Sketching*
Simmonds, Jackie, Wendy Jelbert and Marie Blake, *Need to Know? Drawing & Sketching*
Soan, Hazel, *Gem 10-minute Watercolours*
Learn to Paint Light and Shade in Watercolour
Secrets of Watercolour Success
Trevena, Shirley, *Vibrant Watercolours*
Waugh, Trevor, *Winning with Watercolour*
Whitton, Judi, *Loosen up your Watercolours*

For further information about Collins books visit our website: www.collins.co.uk

INDEX